c h i c a g o

c h i

p a n t h e o n b o o k s

cago

Studs Terkel

new york

Library of Congress Cataloging-in-Publication Data
Terkel, Studs, 1912–
Chicago.

1. Chicago (Ill.)—History—1875–
2. Chicago (Ill.)—Social life and customs.
3. Terkel, Studs, 1912–
I. Title.
F548.5.T37 1986 977.3'11 86-5078
ISBN 0-394-55337-3

For Ray Nordstrand and Norm Pellegrini
and everything they stand for

a c k n o w l e d g m e n t

To Don Gold,
who persuaded me
to write this

c h i c a g o

Away up in the northward,
Right on the borderline,
A great commercial city,
Chicago, you will find.
Her men are all like Abelard,
Her women like Héloise (as in "noise") —
All honest, virtuous people,
For they live in Elanoy.

So move your family westward,
Bring all your girls and boys,
And rise to wealth and honor
In the state of Elanoy.

—A nineteenth-century folk song

When Abe Lincoln came out of the wilderness and loped off with the Republican nomination on that memorable May day, 1860, the Wigwam had been resonant with whispers. Behind cupped hands, lips imperceptibly moved: We just give Si Cameron Treasury, they give us Pennsylvania, Abe's got it wrapped up. OK wit'chu? A wink. A nod. Done. It was a classic deal, Chicago style.

As ten thousand spectators roared on cue, Seward didn't know what hit him. His delegates had badges but no seats. Who you? Dis seat's mine. Possession's nine-tent's a da law, ain't it?

Proud Seward, the overwhelming favorite, was a New Yorker who had assumed that

3

civilization ended west of the Hudson. He knew nothing of the young city's spirit of I Will.

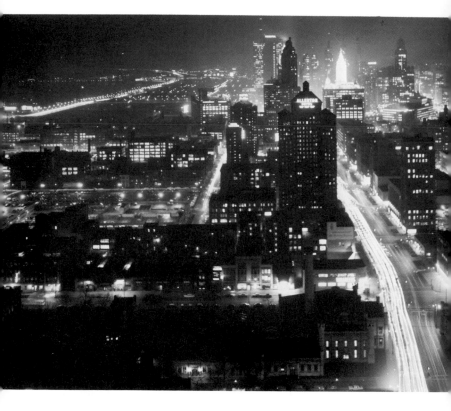

When, in 1920, Warren Gamaliel Harding was similarly touched by Destiny, there had been no such whisperings in the Coliseum. Just desultory summer mumblings (it was an unseasonably hot June: 100 degrees outside, 110 inside; bamboo fans of little use): Lowden, Wood, Johnson. Wood, Johnson,

4

Lowden. Johnson, Lowden, Wood. Three front-runners and not a one catching fire. How long can this go on? Four ballots are enough. C'mon, it's too hot for a deadlock. Shall we pick straws?

But this wasn't just *any* convention city. This was Chicago. Never mind the oratory. Yeah, yeah, we know about the Coliseum where, in 1896, the cry was Bryan, Bryan, Bryan as the Boy Orator thundered eloquently of crowns of thorns and crosses of gold. Nah, nah, let's settle this Chicago style.

A hotel room not far away.

The Blackstone, so often graced by Caruso and Galli-Curci during our city's lush opera season, was on this occasion beyond grace. Nah, nah, it's too hot. Maybe the Ohio Gang ran things that day, but with H. Upmanns blowing curlicues heavenward in the smoke-filled room, the deal—Harding, OK?—was strictly My Kind of Town, Chicago Is.

Yet, along came Jane Addams. Was it in 1889 that she founded Hull-House? The lady was out of her depth, they said. Imagine. Trying to change a neighborhood of immigrants, scared and lost, where every other joint was a saloon and every street a cesspool. And there was John Powers, alderman of the Nineteenth Ward, running the turf in the fashion of his First Ward colleagues, Bathhouse John and Hinky Dink. Johnny Da Pow, the Italian im-

migrants called him. He was the Pooh-Bah, the high monkey-monk, the ultimate clout. Everything had to be cleared through Da Pow. Still, this lady with the curved spine, but a spine nonetheless, stuck it out. And something happened.

She told young Jessie Binford: Everything grows from the bottom up. This place belongs to everybody, not just Johnny Da Pow. And downtown. No, she told Jessie, I have no blueprint. We learn life from life itself.

So many years later, years of small triumphs and large losses, Jessie Binford, ninety, is seated in a small Blackstone Hotel room. The Blackstone again, for God's sake? It isn't a smoke-filled room this time. My cigar, still wrapped in cellophane, is deep in my pocket. It's an H. Upmann—would you believe it? The old woman, looking not unlike Whistler's Mother, is weary and in despair. The wrecking ball had just yesterday done away with Hull-House and most of the neighborhood, as well as the beloved elm beneath her window.

The boys downtown tried to buy off Jessie Binford. You can live at the Blackstone as our guest for the rest of your life, they told her. Anything to keep her quiet. She and a young neighborhood housewife, Florence Scala, were making a big deal out of this. Sshhh. But they wouldn't shush, these two.

These two.

Florence Scala, first-generation Italian-American. Her father, a tailor, was a romantic from Tuscany. He was a lover of opera, of course, especially Caruso records, even the scratchy ones. He had astronomy fever, too, though his longing to visit the Grand Canyon transcended his yen to visit the moon. He was to make neither voyage. The neighborhood was his world and that was enough.

For Florence, her father's daughter, the neighborhood reflected the universe, with its multicolors, its varied immigrant life, its circumambient passions.

Jessie Binford, of early Quaker-American stock. Her father, a merchant, trudging from Ohio to Iowa in the mid-nineteenth century, found what he was looking for. The house he built in 1874 "still stands as fundamentally strong as the day it was built," his daughter observed. At the turn of the century, she found what *she* was looking for: a mission, Hull-House, and a place, Harrison-Halsted. She found the neighborhood.

For Florence Scala and Jessie Binford, Harrison-Halsted was Blake's little grain of sand.

They passed one another on early-morning strolls along these streets, not yet mean. They

came to know one another and value one another, as they clasped hands to save these streets. They lost, of course. Betrayed right down the line. By our city's Most Respectable.

"I'm talking about the boards of trustees, the people who control the money. Downtown bankers, factory owners, architects, people in the stock market." Florence speaks softly and that, if anything, accentuates the bitterness.

"The jet set, too. The young people, grandchildren of the old-timers on the board, who were not like their elders, if you know what I mean. They were not with us. There were also some very good people, those from the old days. But they didn't count any more.

"This new crowd, these new tough kind of board members, who didn't mind being on the board for the prestige it gave them, dominated. These were the people closely aligned to the city government, in real estate and planning. And some very fine old Chicago families." As Florence describes the antecedents of today's yuppies, she laughs ever so gently. "The nicest people in Chicago."

|||||| |||||| ||||||

Miss Binford is leaving Chicago forever. She had come to Hull-House in 1906. She is going

home to die. Marshalltown, Iowa. The town her father helped found.

The blue of her eyes is dimmed through her spectacles. Her passion, undimmed. "Miss Addams understood why each person had become what he was. She didn't condemn because she understood what life does to people, to those of us who have everything and those

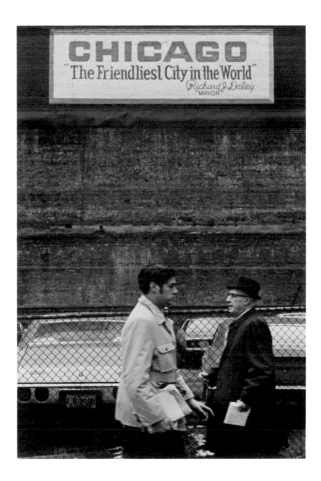

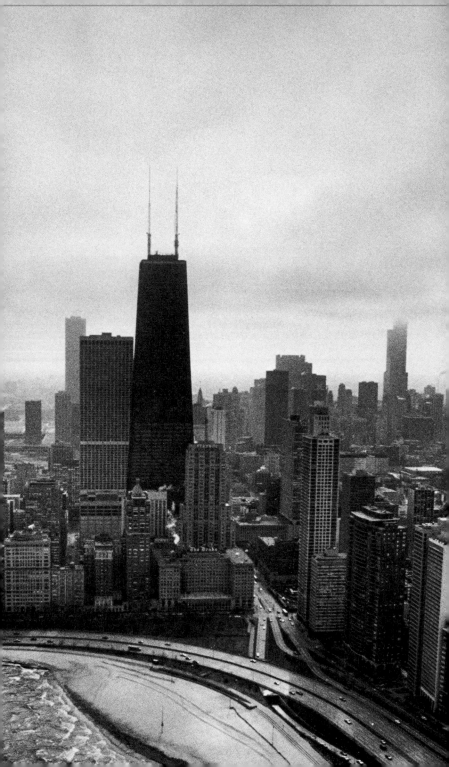

of us who have nothing." It's been a rough day and her words, clearly offered, become somewhat slurry now. "Today we're getting further and further away from this eternal foundation on which community life must rest. I feel most sorry for our young people that are growing up at this time—" It's dusk and time to let her go. I press the STOP button of my Uher.

Another Chicago voice. Stilled. And yet . . .

Janus, the two-faced god, has both blessed and cursed the city-state Chicago. Though his graven image is not visible to the naked eye, his ambiguous spirit soars atop Sears, Big Stan, and Big John. (Our city is street-wise and alley-hip of the casually familiar. Thus the Standard Oil Building and the John Hancock are, with tavern gaminess, referred to as Big Stan and Big John. Sears is simply that; never mind Roebuck. Ours is a one-syllable town. Its character has been molded by the muscle rather than the word.)

Our double-vision, double-standard, double-value, and double-cross have been patent ever since—at least, ever since the earliest of our city fathers took the Pottawattomies for all they had. Poetically, these dispossessed natives dubbed this piece of turf *Chikagou*.

Some say it is Indian lingo for "City of the Wild Onion"; some say it really means "City of the Big Smell." "Big" is certainly the operative word around these parts.

Nelson Algren's classic *Chicago: City on the Make* is the late poet's single-hearted vision of his town's doubleness. "Chicago . . .

forever keeps two faces, one for winners and one for losers; one for hustlers and one for squares. . . . One face for Go-Getters and one for Go-Get-It-Yourselfers. One for poets and one for promoters. . . . One for early risers, one for evening hiders."

It is the city of Jane Addams, settlement worker, and Al Capone, entrepreneur, of Clarence Darrow, lawyer, and Julius Hoffman, judge; of Louis Sullivan, architect, and Sam Insull, magnate; of John Altgeld, governor, and Paddy Bauler, alderman. (Paddy's the one who some years ago observed, "Chicago ain't ready for reform." It is echoed in our day by another, less paunchy alderman, Fast Eddie.)

Now, with a new kind of mayor, whose blackness is but one variant of the Chicago norm, and a machine—which like the old gray mare ain't what it used to be—creaking its expected way, all bets are off. Race, though the dominant theme, is but one factor.

It is still the arena of those who dream of the City of Man and those who envision a City of Things. The battle appears to be forever joined. The armies, ignorant and enlightened, clash by day as well as night. Chicago is America's dream, writ large. And flamboyantly.

It has—as they used to whisper of the town's fast woman—a reputation.

Elsewhere in the world, anywhere, name the city, name the country, Chicago evokes one image above all others. Sure, architects and those interested in such matters mention Louis Sullivan, Frank Lloyd Wright, and Mies van der Rohe. Hardly anyone in his right mind questions this city as the architectural Athens. Others, literary critics among them, mention Dreiser, Norris, Lardner, Algren, Farrell, Bellow, and the other Wright, Richard. Sure, Mencken did say something to the effect that there is no American literature worth mentioning that didn't come out of the palatinate that is Chicago. Of course, a special kind of jazz and a blues, acoustic rural and electrified urban, have been called Chicago style. All this is indubitably true.

Still others, for whom history has stood still since the Democratic convention of 1968, murmur: Mayor Daley. (As our most perceptive chronicler, Mike Royko, has pointed out, the name has become the eponym for city chieftain; thus, it is often one word, "Maredaley.") The tone, in distant quarters as well as here, is usually one of awe; you may interpret it any way you please.

An English Midlander, bearing a remarkable resemblance to Nigel Bruce, encounters me under London's Marble Arch: "Your mayor is my kind of chap. He should have

bashed the heads of those young ruffians, though he did rather well, I thought." I tell him that Richard J. Daley died several years ago and that our incumbent mayor is black. He finds this news somewhat startling.

"Really?" He recovers quickly: "Nonetheless, I do like your city. I was there some thirty-odd years ago. Black, is he?"

Yeah, I tell him, much of the city is.

He is somewhat Spenglerian as he reflects

on the decline of Western values. "Thank heavens, I'll not be around when they take over, eh?"

I nod. I'm easy to get along with. "You sound like Saul Bellow," I say.

"Who?"

"Our Nobel laureate. Do you realize that our University of Chicago has produced more Nobel Prize winners than any other in the world?"

"Really?"

"Yeah."

He returns to what appears to be his favorite subject: gumption. "Your mayor had it. I'm delighted to say that our lady prime minister has it, too."

I am suddenly weary. Too much Bells Reserve, I'm afraid. "So long, sir. I'll see you in Chicago."

"Not likely; not bloody likely."

In Munich, a student of the sixties, now somewhat portly and balding, ventures an opinion. Not that I asked him. Chicago does that to strangers as well as natives.

"Your Mayor Daley vas bwutal to those young pwotesters, vasn't he?"

Again I nod. Vat could I say?

But it isn't Daley whose name is the Chicago hallmark. Nor Darrow. Nor Wright. Nor is it either of the Janes, Addams or Byrne. It's Al Capone, of course.

In a Brescian trattoria, to Italy's north, a wisp of an old woman, black shawl and all, hears where I'm from. Though she has some difficulty with English (far less than I have with Italian), she thrusts both hands forward, index fingers pointed at me: *Boom, boom*, she goes. I hold up my hands. We both laugh. It appears that Jimmy Cagney, Edward G.

Robinson, and Warner Brothers have done a real job in image making.

Not that Al and his colleagues didn't have palmy days during what, to others, were parlous times. Roaring Twenties or Terrible Thirties, the goose always hung high for the Boys. I once asked a casual acquaintance, the late Doc Graham, for a résumé. Doc was, as he modestly put it, a dedicated heist man. His speech was a composite of Micawber and Runyon:

"The unsophisticated either belonged to the Bugs Moran mob or the Capone mob. The fellas with talent didn't belong to either one. We robbed both."

Wasn't that a bit on the risky side?

"Indeed. There ain't hardly a one of us survived the Biblical threescore and ten. You see this fellow liquidated, that fellow—shall we say, disposed of? Red McLaughlin was the toughest guy in Chicago. But when you seen Red run out of the drainage canal, you realized Red's *modus operandi* was unavailing. His associates was Clifford and Adams. They were set in Al's doorway in his hotel in Cicero. That was unavailing."

Was it a baseball bat Al used?

"You are doubtless referring to Anselmi and Scalisi. They offended Al. This was rare. Al Capone usually sublet the matter. Since I'm Irish, I had a working affiliate with Bugs

Moran. Did you know that Red and his part-
ners once stole the Checker Cab Company?
They took machine guns, went up, and had
an election. I assisted in that operation."

What role did the forces of law and order
play?

"With a bill, you wasn't bothered. If you
had a speaking acquaintance with Mayor
Thompson,* you could do no wrong. Al spoke
loud to him."

In 1923, Big Bill Thompson chose not to run
for a third term. He may have had other in-
terests at the moment. I doubt that he was
scared off by the howled indignations of re-
formers. Whenever Big Bill blew his horn
loudly and flatulently, all other sounds were
muted.

Who remembers today anything his righ-
teous detractors said? Who can forget what
Mayor Thompson said so offhandedly and so
Anglophobically? "I'll punch King George
in the nose!" It was George V he was threat-
ening, the Vandyked little monarch who
wasn't there even when he was there. Had

* Big Bill, the Builder, three-term mayor of Chicago.
He was celebrated for his safety-deposit box and his
credo: Throw Away the Hammer and Pick Up the Horn.

our local Pooh-Bah challenged George's formidable queen, Mary Of The Hats, it might have been more of a challenge: his words against her hatpins.

I forget the occasion of Big Bill's outburst. And the cause. Not that it really matters. A Chicago mayor said it and it made headlines, worldwide. Only Richard J. Daley topped him as an international celebrity. It took six decades to do it.

The heavy one (Thompson weighed a cozy three-hundred-plus and could have given William Howard Taft a caloric run for it) decided to come back in 1927. He won, of course, much to the consternation of the city's decent folk, including a prudish, self-righteous, and horrified fifteen-year-old. I believed all the newspaper editorials inveighing against him (Chicago had about half a dozen of them in those days); not that they were wrong. It was a matter of regarding William E. Dever, the incumbent, as something of a Solon. That Mayor Dever was a most forgettable party hacko was wholly beside the point.

The point was: my brother and I had a memorable time at a Dever campaign rally in 1923. Ashland Auditorium was the site, two blocks from our rooming house. The old hall was usually reserved for gatherings of political outcasts: Socialists, Wobblies, Anarchists, the newly formed Communist Party,

and the like. This night was something else. The Democrat makers and shakers took it over on behalf of De Pee-pul's Choice, Judge Dever; the handsome jurist to rule our city in place of the crude Republican fat boy.

What a night. Long-winded perorations of William Z. Foster, nostalgic ramblings and brags of Ben Reitman, Emma Goldman's lover, and theoretical musings of long-for- gotten Socialists to a hall four-fifths empty were replaced by something of a carnival. And the place was packed. I mean SRO. Busy precinct captains saw to that.

Barnum & Bailey had nothing on them. There were pachyderms, euphemistically called wrestlers: The Terrible Turk, Wild Man Zawicki, Madman Isadore, and Farmer Blunt. Grappling, swinging, grunting, howl- ing, falling. There were two-round boxing matches ending in double knockouts. There were black tap-dancers who didn't know the meaning of the word quit. There was a family of Lebanese acrobats, who never quite made the Keith-Orpheum circuit, let alone the Hagenbeck-Wallace circus. There were jug- glers, dropping no more than three or four dumbbells at a time. There were a couple of hootchie-cootchie dancers, described by the frog-voiced MC as "long-lost nieces of Little Egypt." (My brother swore they were the Hungarian twins he and his buddy Angie had

picked up one night at the Dreamland Ballroom.) There was everything but dancing bears.

There was Crackerjack with a prize in each and every package; free hot dogs; free Baby Ruths; free soda pop (near beer for the big guys); free everything. There were also pennants given away: Dever for Mayor. And all sorts of buttons: Clean Up Chicago. Vote for Dever. What was even more wondrous: my brother and I were not eligible to vote.

When Judge William E. Dever, the man of the hour, appeared, he was introduced by Froggy as The Man of the Hour. Mercifully, he spoke for only a minute. He opened by

asking the question of the century: "Are you having a good time." The response was a ringing and resounding "Yeahhhh!"

How could he lose? He didn't. The magic apparently wore off some four uneventful years later. Big Bill came back for a third time around. Blowing his horn and, like Joshua some time before, blowing down the walls of the enemy.

‖‖‖‖ ‖‖‖‖ ‖‖‖‖

Though Doc Graham had never met Big Bill, he knew the Fat Boy had more than lung power.

"Cash had a language all of its own. One night I didn't have my pistol with me, and a lady of the evening pointed out a large score to me. A squad car came by, which I was familiar with. I knew all the officers. I borrowed one of their pistols and took the score. Then I had to strip and be searched by the policemen, keeping honest in the end as we divided the score."

And who can forget Swinging Billy Mc-Swiggin, one of State's Attorney Crowe's most righteous assistants? His sudden attack of lead poisoning was due not to his law and orderliness; rather to his double-dealing ways. At least, so Al felt. He obviously didn't like it.

And Jake Lingle, sterling reporter of the Colonel's *Trib*. His untimely demise, as Doc would put it, was not due to his crusading spirit. Oh, if those paint-peeled walls of the IC tunnel—where Jake, the high roller, was a sudden X—if they could only talk.

Doc's reflections end on a philosophical note. "For some unknown reason, muscle has been going on since the Roman Army conquered the field with a way of life. If you are unsuccessful in your *modus operandi*, the wind-up is a rude awakening with numbers strung out all over your back. You must employ sagacity, ingenuity, and planning if you care to be in a free society. I am a student of the matter."

Chicago is not the most corrupt of cities. The state of New Jersey has a couple. Need we mention Nevada? Chicago, though, is the Big Daddy. Not more corrupt, just more theatrical, more colorful in its shadiness.

It's an attribute of which many of our Respectables are, I suspect, secretly proud. Something to chat about in languorous moments. Perhaps something to distract from whatever tangential business might have engaged them.

Consider Marshall Field the First. The merchant prince. In 1886, the fight for the eight-hour day had begun, here in Chicago. Anarchists, largely German immigrants, were in the middle of it for one reason or another.

There was a mass meeting; a bomb was thrown; to this day, nobody knows who did it. There was a trial. The Haymarket Eight were in the dock. With hysteria pervasive—newspaper headlines wild enough to make Rupert Murdoch blush—the verdict was in. Guilty.

Before four of them were executed, there was a campaign, worldwide, for a touch of mercy. Even the judge, passionate though he was in his loathing of the defendants, was amenable. A number of Chicago's most respected industrialists felt the same way. Hold off the hooded hangman. Give 'em life, what the hell. It was Marshall Field I who saw to it that they swung. Hang the bastards. Johnny

Da Pow had nothing on him when it came to power.

Lucy Parsons, the young widow of the most celebrated of the hangees, Albert—an ex-soldier of the Confederacy—lived to be an old, old woman. When she died in the forties and was buried at Waldheim Cemetery, my old colleague Win Stracke sang at the services. Though Parsons sang "Annie Laurie" on his way to the gallows, Win sounded off with "Joe Hill." It was a song, he said, that Lucy liked. When I shake hands with Win, I shake hands with history. That's what I call continuity.

The Janus-like aspect of Chicago appeared in the being of John Peter Altgeld. One of his first acts as governor of Illinois in 1893 was an 18,000-word message, citing chapter and verse, declaring the trial a frame-up. He pardoned the three survivors. The fourth had swallowed a dynamite cap while in the pokey.

Though it ended his political life, Altgeld did add a touch of class to our city's history. He was remembered by Vachel Lindsay as Eagle Forgotten. Some kid, majoring in something other than business administration or computer programming, might come across this poem in some anthology. Who knows? He might learn something about eagles.

Eagles are a diminished species today, here as well as elsewhere. On occasion, they

are spotted in unexpected air pockets. Hawks, of course, abound, here as well as elsewhere. Some say this is their glory time. So Dow-Jones tells us. Observe the boys and girls in commodities. Ever ride the La Salle Street bus? Bright and morning faces; *Wall Street Journal*s neatly folded. The New Gatsbys, Bob Tamarkin calls them. Gracelessness under pressure.

Sparrows, as always, are the most abundant of our city birds. It is never glory time for them. As always, they do the best they can. Which isn't very much. They forever peck away and, in some cock-eyed fashion, survive the day. Others—well, who said life was fair? They hope, as the old spiritual goes, that His eye is on all the sparrows and that He watches over them. And you. And me.

||||| ||||| |||||

One year after Warren G. Harding's anointment, almost to the day, a nine-year-old boy stepped off the day coach at the La Salle Street depot. He had come from east of the Hudson and, innocent as Seward, had been warned by the kids on the Bronx block to watch out for Indians. Especially the Black Hawks. The boy felt not unlike Ruggles, the British butler, on his way to Red Gap. Envisioning painted faces and war bonnets.

(I ran into some kids on a street in Kiev, U.S.S.R., in 1981. They rattled on excitedly about Shee-ca-*go* and the Black *Hawks*. They gestured, swinging imaginary hockey sticks.)

August 1921. The boy had sat up all night, but was never more awake and exhilarated. At Buffalo, the vendors had passed through the aisles. A cheese sandwich and a half-pint carton of milk was all he had during that

twenty-hour ride. But on this morning of the great awakening, he wasn't hungry.

His older brother was there at the station. Grinning, gently jabbing at his shoulder. He

twisted the boy's cap around. Hey, Nick Altrock, the brother said. He knew the boy knew that this baseball clown with the turned-around cap had once been a great pitcher for the White Sox. The boy was now in the city where Altrock, Ed Walsh, and Doc White had pitched the Hitless Wonders to a World Series triumph in 1906. The boy's head as well as his cap was awhirl.

Multitudes of other passengers disembarked and were greeted in all fashion—some with delighted screams and wild embraces, others with considerably more restraint, as though a show of emotion were bad manners. Still others, briskly, knowingly, wandered off toward other connections.

There was expensive-looking luggage carried off the Pullmans. Those were the cars up front, a distant planet away from the day coaches. There were cool Palm Beach–suited men and even cooler, lightly clad women stepping down from these cars. Black men in red caps—all called George—were wheeling luggage carts toward the terminal. My God, all those bags for just two people. Twentieth Century Limited, the brother whispered. Even got a barbershop on that baby.

There were straw suitcases and bulky bundles borne elsewhere. These were all those other travelers, some lost, others excitable in heavy, unseasonal clothing. Their talk was broken English or a strange language or an American accent foreign to the boy. Where were the Indians?

This was Chicago, and La Salle was only one of seven such passenger stations, depositing scores of thousands each day, seven days a week. It was indubitably the center of the nation's railways, as the Swede from Galesburg had so often sung out. Chicago to Los

Angeles. Chicago to New Orleans. Chicago to Denver. Chicago to Anywhere. All roads led to and from Chicago. A thousand trains pulled in and pulled out each day. No wonder the boy was bewitched.

An elderly black man, ramrod-backed, was remembering as he puffed away at a dime cigar. He was a retired member of the Brotherhood of Sleeping Car Porters, after thirty years of working passenger trains. It was a casual conversation he and I were having on that August morning, 1963, at the B & O depot. We were both boarding the train that would take us to Washington for the big civil-rights march.

"A Pullman porter could always get into

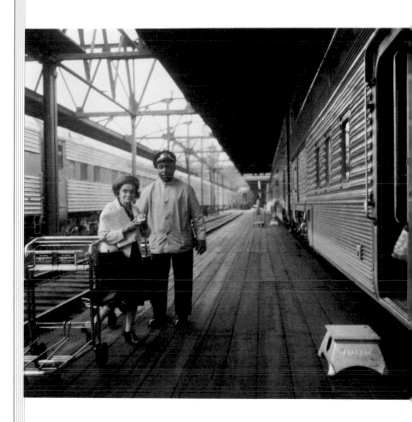

conversation anywhere. He walked into a
barbershop, any city, they'd notice his pants
with a stripe. If he'd come from Chicago,
everybody in the black community listened.
'Cause they knowed a Chicago Pullman porter
been everywhere. In cafés where they ate or
hotels where they stayed, they'd bring in
papers they picked up, white papers, Negro
papers. The *Chicago Defender* was the big
one. He put 'em in his locker and distribute
'em to black communities all over the country.

We were able to let people know what was happening.

"Sure there are fewer Pullman porters today. Railroads have gone downhill all the way. No regard for passengers. When a man bought a ticket in the old days, it was service he bought along with transportation. Cordial treatment. Oh Lord, there used to be trains out of Chicago to anywhere every five minutes or so." He sighs. "Of course, they no longer call us George." He takes a long pull at his cigar and smiles. "Chalk one up for the Brotherhood of Sleeping Car Porters."

||||| ||||| |||||

The Broo-o-otherhood of Sleee-eeeping Car Po-rrr-ters. It is an indelible memory, as even now I hear Carl Sandburg enunciating those words ever so deliberately, ever so slo-o-owly. He is swaying on the stage of the Opera House. It is a June night, 1937. He is about to introduce A. Philip Randolph, founder of the black man's union. A huge crowd has gathered here, in protest of the Memorial Day Massacre.

There had been a holiday picnic on the grounds of the South Chicago plant of Republic Steel. Families of the steelworkers, wives, kids, in-laws, cousins, friends, were celebrating the birthing of the Steel Workers

of America–CIO. Tom Girdler, the company's head man, was among the last holdouts; defying John L. Lewis, defying the Wagner Act, defying the long-repressed dream of the celebrants. He was more defiant than Canute.

Suddenly the Chicago police, on the orders of a Captain Mooney, charged onto the picnic grounds, billy clubs wildly swinging. Guns were drawn. Baskets of fried chicken, pierogi, potato salad, and coleslaw were the picnickers' weapons in a free-fire zone. Nobody knows how many of the celebrants were wounded. Ten were killed. Shot in the back. They hadn't run fast enough.

A friend of mine, Harry Harper, lost an eye. With his David Niven mustache and his dapper dress code, he had become a dead ringer

for the Man in the Hathaway Shirt. It was the black patch over his ex-eye. He didn't seem too appreciative. "I could have lived without it," he said.

The atmosphere at the Opera House was more highly charged than any I had ever experienced. Though I was seated in the very last row, high in the balcony—it was impossible to squeeze any more into the house—I could sense the trembling indignation on the stage. You could taste the wrath of the audience.

Among the speakers—talking bitterness, the Chinese would say—were Paul Douglas, Len Despres, Larry Jacques, the doctor who had tended to the dead and wounded, and, the most passionate of all, Robert Morss Lovett, the gentle professor. He had spent most of his academic life at the University of Chicago, standing up to the know-nothings of his day and teaching his students self-respect as well as literature. He was anything but gentle this night. "Mooney is a killer!" was his refrain. It was taken up by the entire audience. It had become a roar for justice.

At this moment, the poet approached the microphone and improvised, slow syllable by even slower syllable, in introducing A. Philip Randolph, pre-e-esident of the Bro-o-otherhood of Slee-eeee-ping Car Po-o-orters. From the house came the howl: "Get goin', fer

Chrissake, get goin'!" Despite the *shshshe*s and shocked whispers, the heckler was expressing something deeply felt. (Are we capable of such passion today?)

||||| ||||| |||||

I haven't the foggiest notion what became of Captain Mooney. Was he punished? Was he rewarded? Was he instantaneously retired? Professor Lovett may have felt one way about it. Colonel Robert Rutherford McCormick, the One and Only Himself, held a distinctly different opinion. His *Chicago Tribune*, on the day following the killings, offered a photograph. A uniformed policeman was clubbing a fallen, bloodied striker. The caption: Striker Attacks Police.

Some years later, Sergeant Tom Kearney, of the Chicago Police Department, reflects on the event. On his coffee table is a well-thumbed copy of Gunnar Myrdal's *An American Dilemma*.

"I remember the hunger marches, too. The police charged them. At the time, I didn't know whether they were right or wrong. 'Cause things were rather brutal then and you expected that, you know. Sometimes you're disenchanted, you're disillusioned, you're cynical." He laughs as only a sad, dark Irishman can. "It's a corrupt society."

The sergeant is Chicago to the bone. His great-grandfather had come here from the famine country to help build the Sag Canal. The family wound up with a rock farm; rock rich and dirt poor.

"There's something you gotta understand about Irish Catholics in Chicago. Until recently, being a policeman was a wonderful thing. 'Cause he had a steady job and he knew he was gonna get a pension and they seemed to think it was better than being a truck driver.

"Someone had to be police, you know? They sacrificed anything. They just knew that So-and-so in the family would be. It was another step out of the mud. You figured at least you'd have some security. They felt they no longer worked with their hands. They weren't laborers any more.

"A policeman starts out young and very impressionable, and you see people at their worst, naturally. You don't go into the better homes because they're better at hiding things. With the poor, black and white, doors are open, windows are open, hollering, screaming: a release from their frustrations. Naturally, the impression of a young police officer is that they aren't really people—you know, get rid of them."

Perhaps Tom Kearney was thinking of Vincent Maher. Big Vince, when I last ran

into him, was a disconsolate bartender. "Don't ask me why I quit the force. One thing led to another." He takes off on the "rotten pieces of garbage" who gave him a hard time. He can't get them off his mind: the young protesters at the '68 Democratic convention in Chicago.

I buy him a drink. He buys me one. "Each child has a dream. I had two. One was to be a marine and the other was to be a policeman. I'm trying other endeavors now, but I'm not cut out for it. I'm a policeman. It's the most gratifying job in the world. Now—look at me . . ."

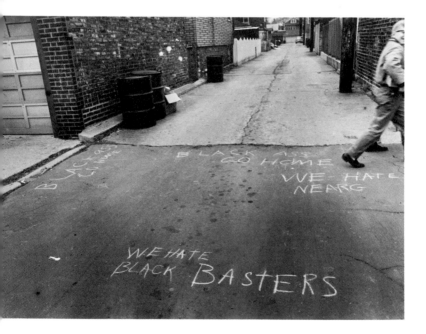

Though Vince is a huge man, his face is a baby's. His lower lip protrudes in the manner of a small child's, terribly hurt.

"I'm human. I make mistakes like everybody else. If you want a robot, build machines. If you want a human being, here I am. I don't think any person doing my job could face the stuff I face without losing your temper at one time or another. I've used the word nigger. I've used the word stump-jumpin' hillbilly. I've used vulgarity against 'em. It depends on the element.

"I've never studied psychology, but I apply it every day of my life. You can go into an atmosphere of doctors, lawyers, and educators and get a point across verbally. They understand. You can also work the South Side, the blacks, where you can talk your fool head off and get nothing. They don't understand this nicety-type guy. So you walk with a big stick. Like the adage of a mule: He's a very intelligent animal, but in order to get his attention you have to hit him on the head with a stick. Same thing applies on the street.

"You really wanna know what a Chicago police officer is? Good cannon fodder. I'm the element that stands between the legitimate person and the criminal. Years ago, he wore a .45 and he was a gunfighter and he wasted people. I don't believe in killing everybody. But I do believe we've gone overboard. They

can shoot a guy like crazy, but we cannot
retaliate. I'm a target for these people. Go
ahead, vent yourself. That's what I'm here
for, a whipping boy. I'm not saying life itself
is violent, but I deal in the violent part of
life."

‖‖‖‖ ‖‖‖‖ ‖‖‖‖

Our rooming house; early twenties. Ashland
and Flournoy. Call it the Near West Side. It
was adjacent to the largest medical complex
in the world. At least, so the Chicago brag
went in those days.

In the same fashion, State and Madison
was "the busiest corner in the world." It was
certainly busy enough for me. When I visited
my brother at the Boston Store on Saturdays,
I was a sardine in the elevator. Five, please.
He was a demon shoe dog, popular with the
kids and especially so with their young, sloe-
eyed mothers.

Most of our rooming-house guests were
out-of-towners, courtesy of Cook County
Hospital. Student nurses, interns, lab tech-
nicians; young country folk, most of them.
And an occasional fast-talking slicker from
Philly or Seattle. Occasionally they found love
in those cramped 60-watt-lit rooms, whenever
they could squeeze in some few short romantic
hours. Occasionally a young doctor of promise

wearied of his smitten Nightingale. Occasionally my precocious brother comforted this distraught young woman in white. My mother began to worry about the rings under his eyes.

IIIII IIIII IIIII

Saturday was his usual night for romance. Aside from offering solace to our young women guests, Mondays through Fridays (on the seventh day, he rested), my brother danced his way from Dreamland Ballroom to more carnalesque quarters (*her* room or apartment) on this celebratory night. On occasion, if she—a file clerk, typist, or salesgirl—lived with "people," he sneaked her into one of our better rooms.

I was his willing accomplice. After an hour or two of post-midnight love, he escorted her home by streetcar, often to the other end of town. It was I who hurriedly changed the linens, so our mother would be none the wiser. I didn't mind this at all, even though it involved my being rousted out of bed in the dead of night. My reward, aside from playing Leporello to his easygoing Don, was the song sheets he brought home.

Each week, Dreamland ushers passed out long pieces of paper with the lyrics of our most popular songs writ upon them. My brother sang them out to me, only to me, in a

melodic tenor. He wasn't Gene Austin. Nor was he Nick Lucas, the Chicago Troubador. Nor Buster Lorenzo, "the little man with the big voice," who sang at the Rialto Burlesque as Peaches did a striptease. But he was okay. Even now, I hear him as he sings, ever so delicately, "In a Little Spanish Town," where it was forever "on a night like this." Or "Yearning." Or "I Wonder Who's Kissing Her Now." Or "My Blue Heaven," of course. There were at least a dozen songs celebrating a girl named Sally. They were usually pleas for her to "come back to our alley" or wondering what ever became of her. Or wondering what ever became of "That Old Gang of Mine." *That* has always been a cause for wonder.

The bands that played at Dreamland were invariably black. Charlie Cooke. Lottie Hightower: they were the two orchestras my brother favored above all others. It was the slow blues they played that so enraptured him, and, I suspect, his dance partner. It enabled them to dance on a dime, rub bellies, and, inexorably, led to other, more vigorous, and no doubt salubrious, endeavors.

My daddy rocks me in a steady jelly roll.
My daddy rocks me and he never lets go.
I look at the clock and the clock strikes eight.
Oh, daddy, take it out before it gets too late . . .

Folklore came as natural to County as over-crowding. It is the case, I suspect, with all public hospitals anywhere in the world. Of all the horror stories making the rounds, the Black Bottle was the favorite. It was whispered among patients— or by the second cousin of a barber who shaved the brother-in-law of a nephew of a former patient—that attendants administered a deadly potion from the Black Bottle to the poor, whenever the joint got too overcrowded.

Today, at County, most of the student nurses and a great many of the young doctors are from another world, the Third. They're from Manila rather than Pittsburgh; from Bombay rather than Davenport. What is constant is its underfunding and overcrowding.

Our rooming house is not there for these other-worlders. Our rooming house is not there for any guest. Our rooming house is not there at all. It is a vacant lot of wild, untended grass and rubble. Not for long. Though on streets named Laflin, Loomis, and Taylor, elderly Italians and a few of their obstinate sons and daughters hang in, signs of gentrification appear. The upwardly mobile young have discovered the neighborhood; so have the developers.

The developers have an acutely developed sense of smell. They need hold no wet finger in the air. They need no divining rod. They simply sniff the air of a neighborhood—close to the Loop, close to where the action is, close to what is *de rigueur* for the young on the make. And so, it's bye-bye, McLaren School.

⫼⫼ ⫼⫼ ⫼⫼

George Malley knew all about developers and their ways. He knew all about "the new people," too, long before the word yuppie had become part of the American lexicon. They were

strange, exotic, and somewhat disturbing to him because never before in his hard-working life had he encountered people so young and so affluent. As from another planet, he saw them as "the new people."

For more than twenty years, he had lived in a frame house on a block that was to become, "almost overnight," the heart of an artsy-craftsy area. "All of a sudden, we started getting this other type: professional people, lawyers, young big shots in advertising, banking, stock-market sharpshooters, artists. You see, we had a period from the lowest to the highest. But the lowest are being priced out."

It had been one of the city's old German—
with a touch of Bohemian—neighborhoods.
Some of the old-timers had been in the same
houses for three, four generations. "I used to
know just about everybody around here.
Now . . ." He waves his hand, helplessly.

"Chicago was a big city before and yet it
was pretty much like a small town. Neigh-
borhood after neighborhood were like small
towns themselves. People integrated, relatives
visited, you talked more, you got to know each
other. Know what I mean? You miss this."

Twelve years later, in 1979, I ran into him
again. He had moved to another part of the
city, a blue-collar community of one- and two-
family dwellings. "They drove me out, this
new breed coming in with their rehabs. These
quite clever young people. Intellectuals, they
were not." He laughs, a buried sort of laugh.
"Pseudo-intellectuals, yes."

How did they drive him out?

"We decided to get out. We were no longer
happy. We didn't speak the same language.
In fact, we didn't exchange the same kind of
looks." He laughs that buried laugh again.
"But I still haven't found what I'm looking
for. I feel lonely."

When I had first met him, George Malley
was preoccupied with the problem of race.
He had been worried about blacks moving
into the old neighborhood. His sons called

him bigoted and narrow-minded. He laughs as he thinks back. "I said, 'Fifteen years from now, you're going to be different persons.' I was right. But I'm the one who changed most dramatically.

"Twelve years ago, I didn't understand things in light of what I see today. I'm surprised at myself. I feel I could live with black people now. Yes, I still worry about violence. But I'm sure the black man has the identical worry, even more so than I have. So we're sharing something in common, see?

"I have learned you better not become too attached to anything. You understand what

I mean? Don't get so attached to something that you can't let go of it. My boys are now accumulating things. They have property now. They're doing fine. The foremost thought in their mind is to protect it. They have to look for someone to protect it from, all right? So God help the first one that gets in their path."

They've become "the new people"?

"Yes." There's that laugh again.

||||| ||||| |||||

McLaren School. Flournoy and Laflin. A stone's throw from our rooming house, assuming Dwight Gooden is doing the throwing. Close enough for me to hop, skip, and jump to it from 1921 to 1925. Like faces in a faded photograph, I see Marco, Jimmy One and Jimmy Two, Orlando, and a kid newly arrived from Naples. We called him Baccalà; he worked in a fish store. Baccalà *(n.):* codfish.

On a day in 1978, I returned to McLaren. Lynn Takata, who teaches schoolchildren how to paint on walls, suggested a look at a mural along the main staircase. Six of the young artists were explaining the work. It was an underwater world, with all sorts of sea animals, some real, some mythic. Wild. The proud artists, ranging in age from nine to thirteen, had names such as Charito, Miguel,

Aki, and Kim. Fifty-three years have seen more than architectural changes in Chicago.

McKinley High School (1925–1928) had experienced similar changes in the student body. On the West Side, my alma mater, Chicago's oldest high school (now no more), entered Booker's name and Willie's on the roster. Marco's people had long since moved to Melrose Park and, if lucky in business, to River Forest. Aside from a change in the pedigree of the teachers (in my time, they were Presbyterian remainders from the turn of the century: i.e., Francis Brimblecome, Olive Leekley, Elmer Potter, George Commons), the big transformation occurred in athletics. *My* McKinley teams lost basketball games by some such score as 54 to 15. The teams of Booker and Willie came on strong to win the

frosh-soph city championship in '52. Talk about academic progress.

There is talk of carting the McLaren mural to the Skinner School, which these kids will henceforth be attending. Wait a minute. What's wrong with McLaren? Nothing's wrong with McLaren; it's just being torn down, that's all. It seems that a hot middle-class housing complex is in the works. True, there had been a promise that McLaren would stand, but let's be pragmatic about it. This area is becoming something worthwhile. Of course, some of the parents are unhappy about it, but they'll get over it.

||||| ||||| |||||

Whether the young McLaren artists know it or not, they're part of an older Chicago tradition that was itself an offspring of an honored Mexican art form: the mural. The work of Rivera, Orozco, and Siqueiros influenced New Deal artists of the thirties, a great many of them in Chicago.

At least 150 pieces of this public art, painted by members of the Arts Project of the WPA, still vivify the walls of Chicago libraries, hospitals, schools, and prisons.

On the walls of the cafeteria at Lane Tech, you may see a huge Mitchell Siporin work. Do the students see it, too, as they have lunch?

Has it ever been discussed in the arts class? In the corridors of Nettelhorst School is a look at Chicago by the cubist pioneer Rudolph Weisenborn. At Lucy Flower, Eddie Millman's *Outstanding American Women* was really outstanding until it was covered over by the authorities. They thought it was too outstanding. If you ever have occasion to mail a package at the Uptown postal station, you'll see the stunning murals of Henry Varnum Poor. And there's John Walley's fire curtain facing the students as they file into the assembly hall at Lane: a rich Indian motif.

Now newer artists, the great many anonymous, have taken to the Chicago streets. It is something beyond graffiti. It is wall art, alfresco. In just about all the neighborhoods, black, white, Hispanic, there is the sign, the mark, the wild color of something fruitful. It may be, in some instances, bitter fruit; in others, sweet. It may be a historic moment in the lives of their ancestors or an outcry or something just for the hell of it, something that says, Look at us, the uniquely us.

Often the works are communally created, the artists rank amateurs. No put-down intended; on the contrary . . . In Miss Leekley's Latin I class, we were taught all about amateurs: *amo*, *amas*, *amat*. I know it has to do with love, and it could be *agape* as well as *eros*. The amateur is a lover. He may not be

Casanova, but he's got the bug. And that ain't bad in neighborhoods where there may be pursuits other than art and love.

Consider a work in Uptown. It's on a Truman College wall. Wilson Avenue is not generally known as an art colony, but consider this one: *Dark as a Dungeon: The Story of*

Coal Mining. Holly Highhill and Barbara Peterson did it with considerable help from the students of Prologue (an alternative) High School. Nineteen seventy-five was the year.

||||| ||||| |||||

It was too late for Buddy Blankenship to appreciate it. A black-lung miner, Buddy had come to Chicago from West Virginia. Uptown, naturally. He was killed in '71. His goofy cousin fired at a neighbor who he felt had slighted him. He was a bad shot and Buddy got it in the chest. I knew Buddy and I know he would have liked that mural. Hell, it was his story.

Buddy's short life in these parts tells you all you need to know about Uptown. Here's how I first remember him: *"Illness has kept him jobless. Children, ranging wide in age from late adolescence to babyhood, stepchildren, son-in-law, grandchild, and a weary wife are seated or wandering about the apartment: trying to keep cool on this hot, muggy summer afternoon. Hand-me-down furniture is in evidence in all the rooms."** I remember

* *Studs Terkel*, Hard Times: An Oral History of the Great Depression *(New York: Pantheon Books, 1970)*, *p. 198.*

the first words of our taped conversation: "I've been in a depression ever since I've been in the world."

I met Buddy through his twelve-year-old kid, Harald. Small, skinny, he could pass for a nine-year-old. You'd recognize the boy if you saw the film *Medium Cool*. Remember the Democratic convention, '68, in Chicago? Haskell Wexler spotted him one day as he ambled along Agatite or some such street, idly kicking at a thrown-away beer can. Harald was a principal actor in the movie, a natural. He was the bright-eyed, introspective son of the young Appalachian heroine. Haskell—all of us—thought Harald was a cinch to make it out of the slough, to break through. Well, he didn't.

About five, six years later, I heard his voice on the phone. I didn't have to see him to know he was beaten. It was the dead tone of a seventeen-year-old loser. He had lost his factory job, was deep in debt, saddled with a sick brother-in-law, a careworn sister, a baby or two. And hardly any schooling. Dame Care had him on the hip. Uptown—they say it can't be beat.

|||||| |||||| ||||||

Uptown has yet to beat Billy Joe Gatewood. Like Buddy and Harald, this nineteen-year-

old had come from the Appalachians. An eastern Kentucky town of shacks and "hollers": population, 2,500. His mother and stepfather had followed one year later. He is one of fifteen children. Work, hard work, has been his lot, ever since he quit high school at the end of his first year.

"Chicago, hit's a place you can labor an' work an' make a livin' at." Small things bother him, though. "There's maybe too many young boys runnin' around. They haven't got nothin' else to do besides running the streets and get alcoholic. They don't have no mother there at home to keep their house clean and to have their meals ready when they come in. So they go out, maybe spend a couple bucks after the evenin' when they get off from work, an' mess around like that."

A caveat: Perhaps I'm assuming too much about Billy Joe's immunity to Uptown's "hollers." It was fifteen years ago when I had last run into him.

"The colored don't worry me. I never had no trouble from them, I never did give them no trouble. If there's a big bunch runnin' around, I don't know if I could get along with 'em or not. I've never associated with 'em. I've heard tell of one colored family moved on this block. It doesn't bother me as long as they stay on their side of the street and I stay on my side of the street."

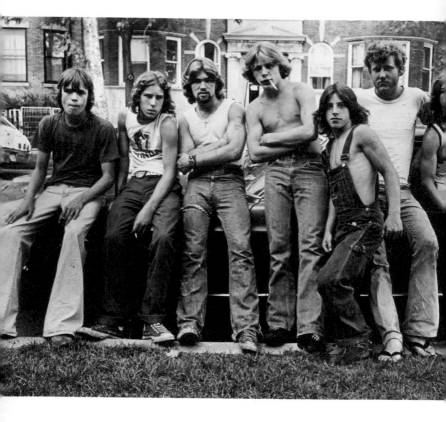

Suppose they're on the same side of the street?

He laughs. "I imagine we might be able to be pious and get along pretty good."

His mother, bearing a startling resemblance to Ma Joad, interjects, "The same sun would shine on both of 'em wouldn't it?"

One block away, in a furnished three-room flat, for which she pays by the week, lives Bonnie Dawson. She's thirty-four, going on

fifty. Bonnie had come to the Big City from Pike County, Kentucky, no more than a spitting distance from Billy Joe's town. With an ailing husband (black lung, of course) and six kids, she's the sole support of the family. She works as a machine operator in a plant

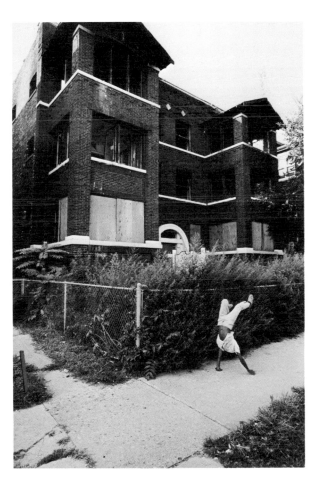

somewhere in the western suburbs: the only woman on the floor. "I ride with the guys works out there."

"I get up about a quarter to five. Don't get home till about seven. When I get home, I cook, wash dishes, sweep up. Go to bed about eleven. Wash dishes, make the bed, cook, clean the house, bathe the babies, pin up my hair—why, it's eleven o'clock. You don't know

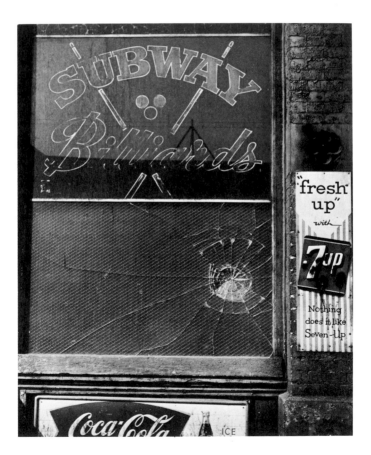

where it went. I work myself to death on Saturday and Sunday, catching up with my back housework. Sunday is my catch-up day, I enjoy it. I never been Downtown. Two years and never been Downtown." She laughs.

Ever hear of Marshall Field's?

"No."

You know what it is?

"No. But I been to the Lincoln Park zoo once." Again, she laughs.

"Oh, I apologize. I been to State Street once. Me an' a girl friend. We took a subway there. Lookin' for employment."

Ever hear of the Bomb?

"I've heard tell of it. Don't worry about it. I got no time to worry about it. I got too much work to do."

I doubt whether Bonnie Dawson is aware of the mural in her neighborhood: the one celebrating Buddy Blankenship and her husband and, perhaps, her father, too.

When it comes to art on the walls of Chicago streets, the work of William Walker springs to mind. This black man of indeterminate age is the master. He's the one the others point to.

Walker's masterwork, *Wall of Respect*, is no longer on the corner of Langley and 43rd. Started in 1967 and finished in '69, it set off

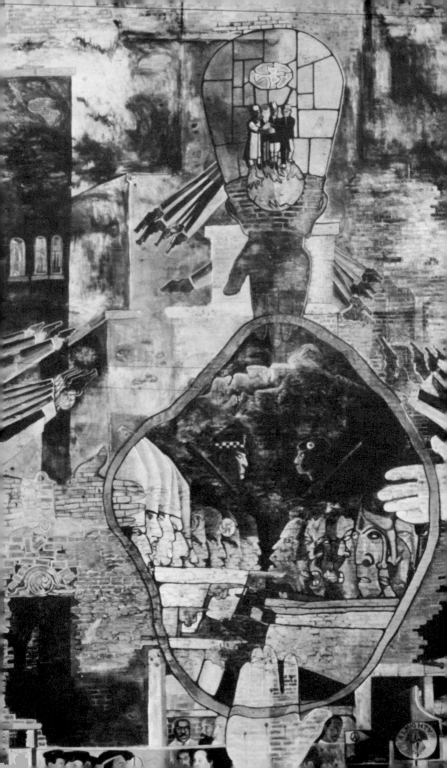

the wildest, most exciting street wall art movement in the country. Right here, on Chicago's South Side.

Walker asked the neighborhood people to choose the heroes of his work. So they did: Ali, Malcolm, Mahalia, Muddy, Dr. King . . . you get the idea. Fire gutted the building. And the *Wall*. A few panels were saved and appear on the campus of Malcolm X College. But it's not the same.

I see him now, this William Walker. As I approach the corner of Locust and Orleans, I see a man high on the scaffold, painting away on the building wall. At first I thought he was just a painter, like Slappy Hooper, doing a job for Sloan's Liniment or the Jim Dandy Hot Stove Company.* A skilled craftsman, but that's it. No, this one is something else. I am stunned by what I see. He calls it *Wall of Understanding*. This was 1970.

If you pass by the corner of 49th and Wabash, nobody will bite you. You'll see something astonishing. It won't make the six-o'clock news or a Murdoch headline, but it'll

* Slappy Hooper, the Wonderful Sign Painter *(Boston: Houghton Mifflin Co., 1946) is a delightful children's book based on old folksay and folklore. It was written by Jack Conroy, the capacious-hearted writer and editor, who was always there with tips and encouragement for any young hopeful who hit the turf here in Chicago.*

do for me. It's the master's *History of the Packinghouse Worker*. A textbookful of commentary on life in Packingtown.

Hog Butcher for the World. Not any more, Carl. Not for some time. The song is ended, though for a visitor from far off the melody lingers on. Vere are the shtockyards? may be his first question. I'll tell you, Günter or Jean-Louis or Marcello or Niels. Cattle and swine are no longer shipped on the hoof. They are done in close to the feedlots in such places as Greeley, Colorado; Logansport, Indiana; Guyman, Texas; and Clovis, New Mexico. *Sic transit gloria porko.*

Eva Barnes, all three hundred pounds of her, remembers her days at the yards. "I worked every job. Pork trimmer. Laundries. I even worked in offal. It's where all the guts and everything. You'd get the hog itch. I was sick to my stomach and my children would say when I got home, 'Mommy, we love you but you smell awful.'" When Eva laughs, the walls of her Oak Lawn frame shake. "But I'll never forget this Dick White. He was colored. He saved my job. He said, 'You'll get used to it. Just don't think that that's what it is. Pretend it's some flowers or something.'" Eva laughs a lot. "And I got used to it . . . This was in the Depression. Then we started organizing the women. I had forty women the first day I went out."

Let's not forget Diego Rivera's Chicago kinsmen. Aurelio Díaz. He is our Chicano master of wall art, though his colleagues, Patlán, Moya, Cortez, and Vega, are not to be sneezed at. I accidentally stumbled across *Leyenda de América Latina*. A huge mural. It is a celebration of some sort—of what? Of the world's beginning? Of glory? So help me, it's a Gabriel García Márquez story come to the wall. On Laflin and 21st. Right across the street from Benito Juárez High School. Poetically as well as geographically on the button.

And along Milwaukee Avenue and other Northwest Side outsides, you'll find an authentic Caryl Yasko. And John Weber. And Kathy Kozan and Sachio Yamashita. By the time this rambling essay appears, who knows how many of these works-that-light-up-the-street will still be up? Things in this town come fast and go fast, man.

Hélène de Nicolaÿ saw that at once. She was working for *Réalités* (a swank French art journal?). "Among the waste lots and semi-demolished buildings of Chicago, I came across a new form of art. Many of the artists are unknown and some of the murals are collective works created by entire communities. When I returned a few weeks later, many of them had disappeared along with the walls.

They had appeared mysteriously, like flowers on a bomb site. Here, among the rubble and rust, it springs to life like a one-day lily."*

||||| ||||| |||||

The work of Picasso, another artist, appears to be more permanent. At the Civic Center Plaza, on that delightful spring day, the master's gift to Chicago is unveiled. It's crowded: old people on benches, grabbing a piece of the sun; file clerks brown-bagging their lunch; school kids; neighborhood folk in town to see what the excitement's all about; and more city workers than usual. It had been suggested by The Man on Five that their presence would be appreciated. And a few street people.

There have been speeches by Maredaley and by the Skidmore architect who persuaded the master to give it to us, and a poem read by Gwendolyn Brooks. As the sheet is tugged off, we see it. There is no gasp from the assemblage, though a slight bewilderment is in the air. A murmur of one sort or another is heard. Is it a bird? A woman? Victory? Which is the front and which is the back? I dunno; ya can't prove it by me.

* *Quoted in Victor R. Sorell, ed.,* Guide to Chicago Murals: Yesterday and Today.

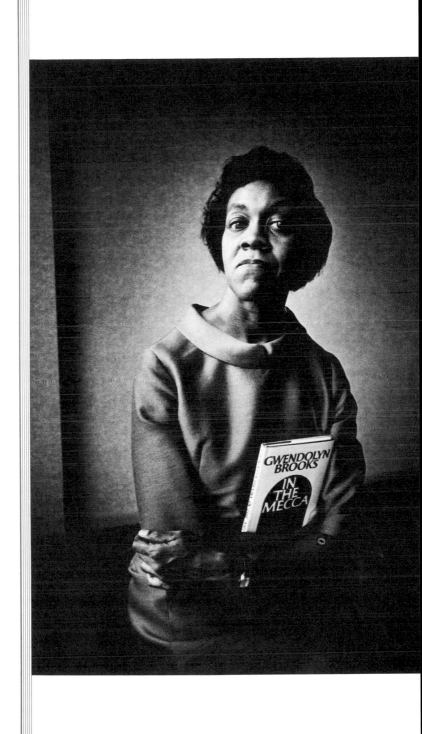

"It's an Afghan dog," says a young woman carrying a Harlequin paperback. "I read somewhere his mistress has such a dog. I guess that proves he loves her."

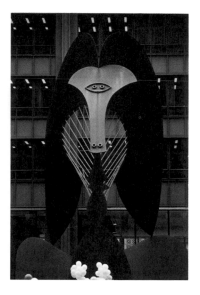

"Oh, it's a woman, definitely a woman," says a large neighborhood matron, as voluble as her even larger husband is silent. "Look, the other side, same thing, a woman. Right, Chester?" Chester nods solemnly.

"Pardon me, sir. Are you with a radio station?"

Yessir.

"May I offer you my humble opinion?"

You bet.

"I'm a lawyer. I accept Picasso as a fine artist, got a great world reputation. But you see those railings? Children can climb up those bars, fall down, and get hurt. I believe they can sue the city. In legal terms this is an attractive nuisance." He *did* say it was attractive.

"Vat iss it?" She is small-boned, intense, with—would you believe?—pince-nez glasses. "I don't know vy iss all the raving aboudt it. I'm from Vienna, but vunce I wisited the Louvre in Paris. Vass you ever in the Louvre? I saw Rembrandt. It vasn't like this."

Shorty, with a *Racing Form* folded under his arm, joins us. "Know what I think?"

What do you think?

"I think it's somethin' ya ate last night that didn't agree with ya. Like after a hard night."

The Louvre lady giggles. "A hard night, dot's good. Yah, dot's funny."

I didn't think it was *that* funny.

She approaches him. Has she smelled his breath? One hundred proof.

"Vass you ever in the Louvre?"

"What is it?"

"The best art museum in the vorld."

His civic pride is challenged. "We got one here on Michigan. The one with the lions. Don't tell me about art."

‖‖‖ ‖‖‖ ‖‖‖

The Chicago Art Institute. Where else can you spend Sunday in the park with George? Seurat, hurrah. *La Grande Jatte* has been seen by more visitors than any other. Diffident, shy, they who have never been in an art museum in their lives approach the guard: Where's the one with the dots?

René Clair, the French film director, had the same impulse. He made it a point, when heading out to the Coast, to always stop off at Chicago. For one purpose only. Seeing *La Grande Jatte*, he said, "satisfies my soul. When I think of this painting, I think of Chicago. The Hollywood producer can wait."

And Hopper's *Nighthawks*. There it is.
The all-night beanery. The hunched back of
the customer at the counter. The weary coun-
terman. The couple, sharpies, perhaps; night
people, absolutely. And that shaft, that sliver
of light outside. It's lonely enough as it is,
but that light sharpens the ache. Edward
Hopper had no time for excess. There it is.

The all-night beanery, below the Wells-
Grand Hotel. (After the rooming-house days,
my mother became an *hôtelière*. Oh, boy.)
There's this restaurant Victoria #2: Mike
Legdas, proprietor. Here is where our guests
—a journeyman carpenter, retired, or a
boomer fireman, retired, or the foreman of a
gang distributing Goldblatt sale circulars—
would grab a bite. Here, as in Duffy's Tavern,
the elite would meet to eat.

And here, on celebratory nights, Fridays usually, I'd have apple pie à la mode at one o'clock in the morning. And here was that one other customer, a loner with his back hunched toward his graveyard stew: bread soaked in a bowl of milk. It was Sprague, an ex-IWW organizer, who got his teeth knocked out by vigilantes in the Seattle general strike some years before. He had to gum his grub. And here was Elmer, the counterman, weary as hell. And—oh, yes, out there was a painted woman, alone and wretchedly awaiting a John, posing under the light—sister, perhaps, to the nighthawk at the counter. It was life imitating art. Oh, that Hopper.

Yes, my bottle baby at the Civic Center Plaza was right. We do have an art museum; never mind the Louvre, lady.

||||| ||||| |||||

The Wells-Grand Hotel. Our landlord was Henry L. Flentye, an old William McKinley Republican. Visiting his basement office on north La Salle, during times when the new lease was drawn up, was always a memorable experience. H. L. had no telephone; he insisted that both parties, on these solemn occasions, face one another. He never used phrases such as *vis à vis;* his language as well as his credo was simple: "I only deal with a man

face to face." He liked my father's face. Though my politics, like my father's, was a blend of Bob La Follette progressivism and Gene Debs socialism, I developed a deep and abiding affection for this man. As did my father.

Need I add that the leases were all written in longhand? And what a handwriting H. L. had! Pure Palmer penmanship. He used a Waterman, of course. It was a delight to read them; and to sign them.

During the Depression, Mr. Flentye was remarkably liberal, understanding, and kind in adjusting the rents. He was as dispirited by the startling appearance of our VACANCY sign as we were. (We had always a waiting list of craftsmen-guests until the Crash changed everything.) He no longer mentioned Hoover's name; he spoke only of "cycles, Sam, damnable cycles." And always, he tried to lift my father's sagging spirits.

With my mother's appearance, after my old man's death, it became a different story. An aggressive woman was not within H. L.'s province. "Your mother," he told me, "thinks she's Hetty Green. I never did like Hetty Green. Nor did I like the Everleigh Sisters, either." It was the only cheap shot Henry L. Flentye ever took. He was implying, of course, that my mother winked at couples who on occasion appeared without baggage. She did

wink. Of course. Still . . . Oh, but I do miss Mr. Flentye.

It's exquisite irony that the Wells-Grand Grill, just below, where Victoria #2 once served Sprague, the old Wobbly, has become an "in" place for yuppie Republicans. Henry L. Flentye would not have given them the time of day. It has become a popular spot for the other party's hackos, too. The line of demarcation between the two is hardly visible. Yet the gap that separates Now from Then is considerably wider than a church door and deeper than a well.

||||| ||||| |||||

The Picasso. A young Maryknoll nun softly murmurs, "It's just beautiful. I can't explain it. It's airborne. And so graceful. Astonishing." Amazing Grace, perhaps?

On the bench, the wizened old-timer has some difficulty with my question, as I shout in his ear. My mike dangles, hopefully. What do you think of this statue, sir?

"Heh, heh." This one really cackles. "I'll bet you I'm the oldest person here. I was ninety just last week."

Congratulations.

"Yep. Do you know, I delivered Western Union messages on roller skates. Lake Street, just down there."

7 8

Terrific. I'm shouting, What do you think of that statue?

"Heh. You know what they'd pay for that?"

For what?

"A telegraph boy. It wouldn't buy a pack of chewngum today. Oh, yeah, them were the days. Yep."

That's by a famous artist, Pablo Picasso.

"Yeahhh." He breathes, with some effort. "How come it's crowded today? I used to have this bench all to myself. Y'know?"

Yeah, I know. Well, that's how it goes.

Somebody in the crowd motions me toward a blonde of indeterminate years who appears to be lecturing to a group near the statue. She's a cross between Sophie Tucker and Zsa Zsa Gabor.

"Watcha got there, dahlink? Your lunch?"

My Uher tape recorder *does* bear a vague resemblance to an old-time lunch bucket.

"Dahlink, I'm in show business, too."

What do you think of it? I *point* at the Picasso. She follows my finger.

"You know vat I told the people here?"

Vat?

"I said, Vere's the American flag? I don't see no flag. I said it just like that; nobody told me. See, up there, there's a flag now. Salute the flag, everybody."

She salutes.

Two men standing toward the rear back

off slightly as I approach. "We work for the city," one says.

What's your opinion?

"Could be worse. Could be Hoagy Carmichael or somep'n."

Stokely C had been raising some sort of fuss in town a week or so before.

The other says, "You want my opinion? If it's good enough for Maredaley, it's good enough for me."

A few years later, I asked Annie. Or was it Bertha? Call her a bag lady, if you're so inclined. She was seen on more than one occasion near the masterwork.

Holding up pretty well, isn't it?

"Oh, yeah. It's great to snuggle under at night. When it ain't too cold."

||||| ||||| |||||

I hope Elizabeth Chapin got around to see the Picasso. I know she'd have delighted in the sight and all that surrounded it. The widow lived in the same frame house since 1908. A tidy place: a blooming geranium garden in the back yard. One of those old German neighborhoods. It's changed a bit since then.

For better or for worse? Who's to say? If you have a Spanish accent and you came from San Juan to find something to feed the kids and have a roof over your head, you've got one

opinion. Same goes for someone who came from Scott, Mississippi, or Boone, Kentucky, white or black.

Did you know when a Southern white meets a Southern black, say in Uptown or in the vicinity of Mrs. Chapin's house, and they discover they're from the same county, all they talk about is "back home"? "Back home" is not where they are, somewhere on Leland or Wilson. "Back home" is where they came from. They are still strangers in a strange land, no matter how long they've been up here. And if they're told ever since the day of arrival that they're something other than "normal," they become something other than

"normal." And their children, of course, become something *really* else.

Elizabeth Chapin didn't judge others. She wondered why it is that "people's eyes are closed with a film over them. Why is it?" She went along with Keats about beauty being truth and the other way around. Up in years or not, she still got around, seeking beauty.

"Lady downstairs. I said put on your hat and I took her to the Art Institute. She hadn't been there in thirty-five years. These things are in our hands and we don't use them. A month doesn't go by when I don't go to the Art Institute maybe for an hour or so. It refreshes your mind. And Lincoln Park, all that lovely greenery."

Much of that afternoon in the old house, the widow was lamenting, much as Jessie Binford did on her last day at the Blackstone, "Don't cut off the nice things of the past. Why are they tearing down those old landmarks, the buildings, the trees? I don't call that progress."

Maybe it's not progress to her, but it is to others. When they destroyed the old Hull-House area with its polyglot talkers and polycultures and the old world and new world breathing together, it was done in the name of a university in the city. Not to mention the names of cement contractors and brokers and

all sorts of breakers. When that bulldozer demolished Jessie Binford's favorite elm, the one just under her window at Hull-House, Florence Scala remembers it as the only moment she saw Miss Binford weep. And when Florence asked the bulldozer operator, a guy from the neighborhood whom she'd known for years, why was he doing it, he didn't quite know what she was talking about. "It's my job, fer Chrissake, Florence." All this fuss about the death of a little tree.

‖‖‖ ‖‖‖ ‖‖‖

It was a Saturday afternoon in 1962 and no birds sang. Florence Scala, my young son, and I were strolling down Halsted Street. It was the last day of Pompeii, revisited. A volcano of bulldozers had descended upon the Hull-House complex. Only the main building was left standing, as a museum piece.

The three of us pilgrims were visiting the old shrines about to be destroyed: shops in Greektown, the Socrates School, varied and sundried marketplaces of long-familiar smells of spices and herbs and all fragrances of a felt life. To Florence, the memory is indelible.

"You remember the pastry shop in Greektown? Mrs. Poulos? The delicious sweets she gave us while we sat there? It was her last week. Mr. Drossos joined us. He was the

principal of the Socrates School. I don't know what happened to Mrs. Poulos. Do you know what happened to Mr. Drossos?"

Yes, I do. I had visited George Drossos a year or so after the diaspora (it was his word). He was living out his last few years on the Far West Side. He was much more than a year older. He was lost and dying without his old haunts and old friends. All bulldozed out, they went their separate ways. Gone was the Academy. He called it that: where the old Greek intellectuals of the

neighborhood sat in cafés, discussing politics, art, and life. All gone.

Nostos was the word he used for the feeling that caught at his heart. It derived from *nostalgia* (he pronounced it the Greek way, in four mellifluous syllables): "When you feel a pain because you cannot return. In Greek, anything that is nice, sweet good taste, we call *nostimo*. It partakes of the feeling of *nostos*."

Yes, dear friend Florence, Mr. Drossos died. Old age, someone said. I know better . . .

|||||| |||||| ||||||

That's how come Richard Nickel died. Dick was a young guy with a wild interest in Louis Sullivan. And all those buildings of this Chicago genius. The one whom Frank Lloyd Wright referred to as his "lieber Meister." Sullivan, who gave Chicago its good name as the architectural Athens. Sullivan, who died on skid row, dreaming of the City of Man.

Anyway, when Richard Nickel heard they were tearing down the Stock Exchange Building, one of the jewels in Sullivan's crown, and he saw it becoming sudden rubble, he went down there to save whatever he could. A piece of this, a piece of that. He was a blessed scavenger.

I guess he was down there one day while

the wreckers were still at work. He couldn't wait. He was afraid they'd cart the stuff off, God knows why, and dump it, God knows where. And nobody would ever know that Louis Sullivan ever existed. A guy like Dick got too emotional about things. Anyway, the wreckers didn't see him and all kinds of stuff fell on him and buried him. And he died.

I had met Richard Nickel, oh, maybe a month or so before it happened. The way he talked, oh God, about beauty and past and history and how we must hang on to some things and continuity and all that stuff, I guess you'd have to say he was crazy.

If you look hard enough the next time you attend Second City, you'll find above the entrance some of Louis Sullivan's grace notes. Some of the stone that graced the Garrick Theatre, when I wore my first pair of long pants bought at the Boston Store. Where else?

Elizabeth Chapin remembered those stone works. She wondered why other countries seem to want them and hold on to them and

be proud of them. "I don't call that progress, the need to go on and on and on. To have no *Sitzfleisch*, as we say in German. No repose."

What is the Garrick now? she asks.

A parking lot, I tell her.

The Garrick. Indelible are the images of the two-a-day movie spectaculars. John Gilbert limping toward the outstretched arms of Renée Adorée: the end of *The Big Parade*. The silent desert fortress and all the dead Legionnaires at their posts, noble Ronald Colman, brutal Noah Beery, cowardly William Powell (before *The Thin Man* days): the opening of *Beau Geste*. The innocent embrace of the girl, Herthe Thiele, and her revered teacher, Dorothea Wieck, made foul by the obscene headmistress: the climactic moment of the pre-Hitler classic *Mädchen in Uniform*.

All this I remember in detail, yet I have no memory at all, in detail or in large, of the building Louis Sullivan created. In all these years of my seeing, I never *saw* my own city's lovelies. As Nelson Algren put it, of the city he loved-hated: "There may be lovelier lovelies, but never a lovely so real." Perhaps Chicago's two faces may be reflected here: the widow's in repose and mine in a state of God knows what.

‖‖‖ ‖‖‖ ‖‖‖

Now, the old Palace, on Clark off Randolph, is a parking lot, too. Does memory play tricks on me as I see, through the picture window, the lobby of the adjacent Planters Hotel: a drummer, a Willy Loman, biting off the tip of a cigar as he flirts with the girl behind the counter? I let it pass; something more exciting was about to happen.

My brother and I were ascending heaven, the second balcony of the Palace, and a Friday night's delight: Van & Schenck, the Pennant Winning Team of Songland; Frank Fay, the languid, world-weary comic (to whom William Buckley bears a startling resemblance); Broderick & Crawford (He: Do you mind if I smoke? She: I don't care if you burn); Ethel Barrymore, *grande dame*, in a Barrie sketch, *The Twelve Pound Look*. All this for two bits, a small price for two hours of heaven. How much does two hours at the parking lot set you back?

|||||| |||||| ||||||

Talk about delight. Barry Byrne. He's "the little boy with the adolescent pimples" in Frank Lloyd Wright's autobiography. He had come to work in the great man's Oak Park home-studio. It is in the twilight of an autumn day in 1964, as my Uher's spool is whirring. It is in the twilight of his life, as Barry Byrne

becomes that boy. He is discovering—or perhaps he knew from his first glance at the Oak Park house, so many years ago—the purpose of his life: a search for delight.

He is recalling the house and the great man's five kids racing in and out. The fireplace didn't work. It was cold, no basement. Nothing seemed to work, yet everything did. "It had a sort of magic. It was this feeling of" —he searches for just the right word—"of improvisation. It evoked a sense of delight."

 ‖‖‖‖ ‖‖‖‖ ‖‖‖‖

Sense of delight. No such thing at the building where I work these days. It's one of our newer complexes: Illinois Center, One, Two, Three. Our studios are in Three; as far east of Michigan Boulevard as you can go without drowning. Yet, outside my window, I see men hanging iron. Another structure is rising, designed to obstruct our view of the lake (its sole redeeming feature). It figures.

Barry Byrne, a mild-mannered man, would have gone absolutely bananas—not to mention Frank Lloyd Wright's reaction: violence, I assume—had he experienced a daily trudge through the cattle chutes. Euphemism: underground corridors.

It is an underworld Hades hardly envisioned. Smiling Persephones, who've come

a long way, baby, enter it, Mondays through Fridays, without the slightest trepidation. And so willingly.

To me, growing increasingly Scroogesque, each day is a *Winterreise*, without the snow, the linden tree, the cold (though a chute or two is pneumonia-drafty) or the weather-vane.

Daily, I walk from the bus, cross the boulevard, and enter the funhouse. Immediately, I shuffle, skulk, limp (simulated), galumph (you don't stroll), through the sub-terranean caverns of hair stylists, video-game parlors, fast-food emporiums, adult-food shops (X-rated?), and places with charming French names, peddling God knows what. While this essay was being composed, a new shop was opened: suntan while you wait.

As I make my way toward the ultimate escalator, leading to the ultimate elevator that will take me heavenward, I whistle "East St. Louis Toodle-oo" or "Für Elise" or "I'm Forever Blowing Bubbles." Sometimes I howl "Amazing Grace." I even mumble in tongues. Anything to make the dark journey go faster.

Sometimes, in the manner of an old-time train caller, I holler "Zombie Canyon!" The echo carries. The acoustics are great here. Naturally, I expect a startled or, at least, an irritated response. Nothing. One time, I was

John McCormack singing out "Let us wander, oh my darlin', down Lobotomy Lane" to the tune of "Mother Machree." Nothing. Another time I did Conrad Veidt as Cesare, the somnambulist, in *The Cabinet of Doctor Caligari.* I held forth my hand, brushing it softly against the wall, and slowly, slowly, stalked *misterioso.* Nothing.

One day, I may wear Marcel Marceau whiteface. The hallmark of the classic clown. I doubt whether it will have any effect, but I am determined, heigh-ho, the wind and the rain, to play out the Fool until—until what? Until the sons and daughters of Byrne, Wright, and Sullivan offer us once again a sense of delight. Until such time, what's wrong with standing Mies's dictum on its head? More and more and more is far too much. It is as gross as worship of the Gross National Product.

‖‖‖ ‖‖‖ ‖‖‖

Barry Byrne had been building churches and cathedrals all his worklife. You name the place; he, like Kilroy, was there. Yet it is the thought, the image of Chicago that holds him fast.

"The Chicago I knew was vast and squalid. An inexpressibly dreary city, without any delight. Yet you're caught in a sort of beat; you

always move. Chicago was a place where things were done, a working place. Probably too much so. Yet it had that something that makes *living* in it an experience. To me the delight was to go to Lincoln Park and sit on the breakwater. Of course, it was an escape from horrid surroundings."

There you have it, once more. The two faces. The old architect is building a city in his mind: of natural delights and manmade squalor. Then. Now?

"Chicago now? It's still in the throes of being born. We haven't learned how to create cities. A city should be a place to *live*."

He's possessed by the double-image. "I always feel a chestswelling when I drive along the lake. I always respond to it. Yet I know four blocks over is desperation."

Funny. On more than one occasion, the old man's image pops into my head as I ride the 146 bus along the Outer Drive. Heading south, we approach Oak Street. My chest doesn't swell, but it feels awfully—chesty. On a rough day, the lake's wildness wham-smashes at the beach, as the city's skyline

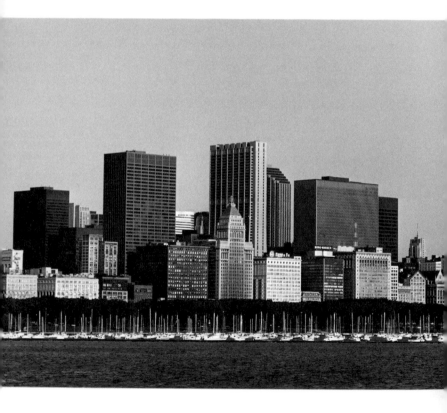

appears through the mist. Appears, hell. It's just *there*. The two phenomena, equally awesome.

On a hot summer day, the lake behaves, the beach is busy, and thousands find cool delight. All within sight of places where ads are created telling you Wendy's is better than Burger King, where computers compute like crazy, and where billions of pages are Xeroxed for one purpose or another, or for no purpose at all. All within one neighborhood. It's crazy and phenomenal. No other city in the world has a neighborhood like this. Visitors, no matter how weary-of-it-all and jaded, are always overawed. You feel pretty good; and, like a spoiled débutante, you wave a limp hand and murmur: It *is* rather impressive, isn't it?

Way down upon the Wabash
Such land was never known;
If Adam had crossed over it,
This soil he'd surely own;
He'd think it was the garden
He'd played in as a boy,
And straight pronounce it Eden
In the state of Elanoy.

But those damn bridges. Though I haven't searched out any statistics, I'll bet Chicago has more bridges than Paris. When up they

go and all traffic stops, you lean against the railing and watch the boats: pulp paper from Canada for the *Trib* and *Sun-Times*, and ore from where?—the Mesabi iron range?—and all sorts of tugs easing all sorts of lake vessels, bearing all sorts of heavy stuff, big-shouldered stuff. You may not feel particularly chesty, yet there's a slight stirring, a feeling of Chicago's connection with elsewhere.

However—and what an infuriating however—when a lone sailboat comes through with two beautiful people sporting Acapulco or Palm Beach tan, she in a bikini and he in

Calvin Klein shorts, and the two, with the casualness and vast carelessness of a Tom and Daisy Buchanan, wave at the held-up secretaries, file clerks, and me, I look around for a rock to throw, only to realize I'm not Walter Johnson, and I settle for a mumbled *sonofabitch* and I'm late for lunch. *Sonofabitch*.

There's no other city like this, I tell you.

And taxi drivers.

When, in eighth-grade geography, Miss O'Brien, her wig slightly askew, quizzed you ferociously on populations of the world's great cities, you had to, with equal ferocity, look them up in the atlas. Thanks to Third World hackies, you can save an enormous amount of time and energy.

You peek up front toward the driver and you see the name Ahmed Eqbal. Naturally, you ask him what's the population of Karachi and he tells you. With great enthusiasm. If his surname is Kim, you'll find out that Seoul is close to seven million. If the man driving at an interesting speed is Marcus Olatunji, you might casually offer that Ibadan is bigger than Lagos, isn't it? If his name has as many syllables as a Welsh town's, you simply ask if Bangkok has changed much; has its population really experienced an exponential growth?

Of course, all short cuts to knowledge have their shortcomings. Sometimes he'll whirl

around, astonished, and in very, very precise British English ask, "How do you *know* that?" A brief cultural exchange ensues as suddenly you cry out, Watch out! We missed an articulated bus with a good one-tenth of an inch to spare. If it's a newspaper circulation truck, God help the two of us.

Chicago's traffic problem is hardly any problem at all—if you forget about storms, light rains, accidents, and road construction—when compared with other great cities. In contrast to New York's cacophony of honks and curses, ours is the song of the open road. Mexico City is not to be believed. Ever been to Paris where the driver snaps his fingers, frustrated, as you successfully hop back onto the curb? Need we mention the Angeleno freeway?

||||| ||||| |||||

I don't believe any city in the world ever experienced as astonishing a moment as Chicago's—being liberated from her beloved demon, the automobile—as during those three days of late January 1967. The Big Chicago Snow-In.

The clean white snow falling, falling . . . a delightful deluge. As though it were all at once, traffic came to a dead stop. Here and there, a lone car ever so slowly, slowly crawl-

ing along. A bus every now and then. Parked cars lovingly covered, buried for a few days under those huge white banks. And Chicago citizens making a startling discovery of their hitherto untouched selves.

People were walking in the middle of side streets, in the middle of major thoroughfares. The sidewalks and the streets were indistinguishable. And strangers talked to strangers and were laughing about this strange, crazy happening. And when somebody fell down, five helped him/her up and laughed again.

The Swiss janitor was softly recalling what happened that first morning. "I was waiting for a bus that never came. This stranger in the only car I saw during the half an hour

says to me, 'Hop in.' People are paying attention to each other. This is the most beautiful thing ever happened to Chicago."

Before we get too euphoric, remember we're still the city of two faces. God may have provided the snow. But the other god, Janus, created our psyche. The supermarket clerk was exhausted. "They mobbed us like the world was gonna end. Their only concern was filling their own need. I got it, my neighbors don't. They drink a quart of milk a week, they'll buy five gallons. You'd've thought the Russians were coming."

When I asked the cop at the Greyhound station what he thought about the weather, came the response: "No comment."

At a Clark Street greasy spoon, the man busy with a stack of pancakes hasn't noticed anything. "I been to the movies all day. Woods, Chicago, State–Lake. I wouldn't know."

What'd you see?

"Pictures."

Notice the fewer cars on the street?

"Mine's one of the fewer."

The bartender in a Loop tavern may have said it all, about Chicago's twoness. "I see dissension. I seen one fellow tryin' to dig out with a board, another fellow pulls up and hands him a shovel. Like I say, people are more surly."

I haven't figured that one out yet.

On the third and last day, the bus is slowly moving along. Everybody is talking animatedly:

I was stuck on a bus six hours yesterday.

Yeah, you too? So what did you do?

We all talked, what else ya gonna do?

A couple even wrote down their names. I got it somewhere in my pocket.

Everybody on the bus is attentively listening as the effusive grandma is addressing one and all, as though offering testimony in a Pentecostal church. "I was with my friend coming from the hospital; her husband had just had his voice box removed. I get to Thorndale and Winthrop; I can barely make it. This man comes up to me and he says to me, 'You're falling down. Upsadaisy, lady.' He walked me all the way home. *Ten blocks.* At a time like this, you can't beat people, that's all there's to it. People are *phenomenal.*"

A nonbeliever in the rear bawls out, "In a week they'll forget the whole thing and go back to their old ways." Mebbe so, mebbe so, as Moms Mabley used to say; that's why I wish God would bless us with another such snow-in.

Win Stracke and I are helping push a cab stuck on Armitage. Two young Japanese, out of nowhere, join us. We push Joe's cab out of whatever it is. Our two sudden col-

leagues shake hands with us and walk away. They didn't know a word of English.

Win and I, mellowed considerably by Jack Daniel's (after all, we were stuck), are riding in the back of Joe's cab. Clark Street. Win, one of our city's unofficial historians, is more historiesque-tongued than usual! "This was the old Indian Sauk Trail and that's what we've been these past three days, Indians. I

saw a fellow in skis yesterday right along this old trail." Now Win's really rolling; there's no stopping him. "Cro-Magnon man walks the streets as he did twenty thousand, forty thousand years ago. Same swallows, whose foliage hasn't changed in millennia, still fly, and man, with a minor catastrophe like this, discovers man as he really is when he's devoid of all these advances of technology. I believe man is basically a cooperative animal."

At that moment, we're on Clark between Dickens and Webster. "The Werner Storage Company," Win observes. "Scene of the Saint Valentine massacre." Boy, oh boy, there's that Roman god again with his two crazy heads.

On the triple corner of Clark, Broadway, and Diversey, we see the *Trib*'s Sunday morning headline: "City Digs to Free Itself." And I thought that's what we were for the past three days: more free than we had ever been in the history of our city.

A Mike Royko addendum to this epochal moment: "I shovel snow, break my back, sleep in my office with a heating pad as pillow and a couple of moonbeams philosophize on the significance of the snow. The real significance? It gave people a chance to stay downtown overnight and get drunk."

|||||| |||||| ||||||

Talk about glory moments. Imagine being on the South Side on the night Joe Louis put away Max Schmeling with a kidney crusher early in round one. Dude and I were there. Hardly a month before tackling this essay, I approached an elderly black man standing on a street corner.

"Pardon me."

He looked up at me curiously.

"Could you tell me what year Joe Louis knocked out Max Schmeling?"

He broke into a million-dollar smile: "Nineteen thirty-eight." Ask any black person of a certain age that question and you can hardly miss.

A June night, 1938. Dude and I are in the front seat of somebody's Chevy. We can barely make out the words on the car radio. Damn! Now it comes through. We hear the excited ring announcer—it's not Graham McNamee, is it?*—Joe hits Schmeling. Max is down, kneeling, moaning. It's over. We leap out of the car. There's little doubt where we're going: the South Side. This minute. Two young white guys.

Dude and I had been buying all kinds of "race records": Vocalian, Okeh, Bluebird. We were hooked on Big Bill, Tampa Red, Memphis Minnie, Big Maceo, Peatie Wheat-

* *It was Clem McCarthy.*

straw, the High Sheriff of Hell, Rosetta
Howard and the Harlem Hamfats. We had
been all over the South Side, haunting record
stores, gallimaufry shops, novelty places.
They went for a nickel or a dime apiece. We
were hopelessly addicted. We were well
acquainted with the streets of blues.

No sad blues on the South Side this night.
God, when we reached 47th and South Park-
way, what a wondrous sight. There was danc-
ing and singing and laughter and everybody
was shaking hands with everybody, as in Sun-

day morning church when the preacher ended his sermon and Mahalia sang her last glorious song. And everybody was slapping everybody on the back, Dude and me included. And there were tears. Crying for joy as well as jumping for it. Jesus, as I think of it now . . .

That night, Dude and I were pulled into barbecue places by elderly women and middle-aged men and young bloods, too. Only they weren't called bloods in those days. All I remember is heaping plates in front of us, in front of everyone else, too. And I don't know how many shots of bar whiskey we had. On the house, of course. Our money was no good. All I remember is a guy joined us during our delighted wanderings. All I remember is his name was Hightower. And he was our buddy that night.

A couple of Caucasian twenty-five-year-olds were witness to one of Chicago's most exhilarating experiences. I wonder what's become of Dude? I wonder what's become of Hightower? I wonder what's become of us? What the hell have we done to a dream?

|||||| |||||| ||||||

So we're reminiscing about one thing or another, Verne and I. Vernon Jarrett knocks out a *Sun-Times* column: reflections of black life in Chicago and elsewhere. I can't get that

Jubilee Night, '38, out of my mind. He tells me of that same celebratory moment in Paris, Tennessee, along the IC tracks. Hallelujah and hope. We see our reflections in the mirror behind the bar and neither of us looks too hopeful. Hallelujah for what?

"The ghetto used to have something going for it," he says. "It had a beat, it had a certain rhythm and it was all hope. I don't care how rough things were. They used to say, If you can't make it in Chicago, you can't make it anywhere. You may be down today; you're gonna be back up tomorrow."

The lyric of an old blues song is rolling around in my head like a loose cannonball:

I'm troubled in mind, baby, I'm so blue,
But I won't be blue always
You know the sun, the sun gonna shine
In my back door someday.

"You had the packinghouses going, you had the steel mills going, you had secondary employment to help you 'get over.'"

Oh, there's still a Back of the Yards, all right, but where are the yards? And Steeltown. Ever visit South Chicago these days? Smokestacks with hardly an intimation of smoke. A town as silent, as dead as the Legionnaires' fortress in *Beau Geste*. Where the executioner's ax fell upon Jefferson and Johnson as upon Stasiak, Romano, and Polowski.

"Now it's a drag," says Verne. "There are thousands of people who have written off their lives. They're serving out their sentences as though there were some supreme judge who

said, 'You're sentenced to life imprisonment on earth and this is your cell here.' What do you do if you've got a life sentence? You play jailhouse politics. You hustle, you sell dope, you browbeat other people, you abuse other cellmates, you turn men into weaklings, and girls you overcome.

"If I'm feeling good and want to have my morale lowered, all I have to do is drive out Madison Street on a bright, beautiful day and look at the throng of unemployed young guys in the weird dress, trying to hang on to some individuality. Can't read or write; look mean at each other. You see kids hating themselves as much as they hate others. This is one thing that's contributed to the ease with which gangs kill each other. Another nigger ain't nothin'."

Is it possible that ol' Hightower, the pub-crawling buddy of Dude and me during those Jubilee hours on a June night so long ago, has a signifying grandson among the wretched and lost on some nonsignified corner somewhere on the West Side?

From the year one we've heard Lord Acton cited: Power corrupts and absolute power corrupts absolutely. You're only half right, Your Lordship, if that. In a town like Chicago, Johnny Da Pow and a merchant prince and, in our day, a Croatian Sammy Glick run much of the turf because of another kind of

corruption: the one Verne Jarrett observed. Powerlessness corrupts and absolute powerlessness corrupts absolutely. You see, Lord A knew nothing of Cabrini-Green. Or—*memento mori*—47th and South Parkway, with exquisite irony renamed Martin Luther King, Jr., Drive. Mine eyes haven't seen much glory lately.

However—there's always a however in the city Janus watches over . . .

Somethin's happenin' out there not covered by the six-o'clock news or a Murdoch headline. There is a percolating and bubbling in certain neighborhoods that may presage unexpected somethings for the up-againsters. A strange something called self-esteem, springing from an even stranger something called sense of community.

Ask Nancy Jefferson. It happened at the Midwest Community Council on the West Side. She's director of this grassroots organization. "This morning I had a young man. He had taken some money from us. I didn't think I'd see him again. I spread the warning: 'Watch out; he's a bad egg.' Today, out of the clear blue sky, he walked into my office. He says, 'I want to pay back my debt at fifty dollars a month. I've gotten a job. I didn't want to see you until I got a job.' I didn't know what made him come back. Was it the spirit of the community?"

In South Chicago, a bit to the southeast, Fast Eddie is finding out about UNO. That's the United Neighborhood Organization. While the alderman was busy giving Harold a hard time, his Hispanic constituents in the Tenth Ward were busy giving Waste Management, Inc., a hard time. The multinational

toxic dumper was about to dump some of the vile stuff in the neighborhood. Hold off, big boy, said Mary Ellen Montez, a twenty-six-year-old housewife. So far, she and her neighbors are doing a far better job than Horatio ever did at the bridge.

UNO's grassroots power is being felt in Pilsen, too, where rehabs are springing up without the dubious touch of gentrification. The community folk are there because they're there and that's where they intend to stay. No shoving out in these parts. And no yuppies need apply.

Farther west, the South Austin Community Council, when not challenging joblessness and street crime, has sent housewives and suddenly redundant steelworkers to Springfield as well as to City Hall to lobby for the Affordable Budget, so that gas and electric bills don't destroy those whom God has only slightly blessed with means. They're not waiting for the hacks to fight for it; they're do-it-yourselfers.

Talk about fighting redundancy, the Metro Seniors are among the most militant. Never mind the wheelchairs, crutches, tea, and sympathy. They bang away everywhere, with or without canes and walkers: Keep your grubby hands off Medicare and Social Security. Ever hear of the time they marched into official sanctums with a cake: Cut the

cake but not the COLA (cost-of-living adjustment)? The hacks ate that cake more slowly and thoughtfully than ever. There are 7,500 such scrappers in town, the youngest sixty-five. They may not have heard "Me and Bobby McGee," but they sure know the lyric: "Freedom's just another word for nothin' left to lose."

All sorts of new people from Central America and Southeast Asia, together with the more settled have-nots, are at it in Uptown with ONE (Organization of the North East). Tenants' rights, lousy housing, ethnic identity —name it; if it's an elementary right, they're battling for it.

And let's not forget all those nimble neighborhood organizers coming out of Heather Booth's Midwest Academy. Their style is sixties hipness, Saul Alinsky's Actions (political jujitsu, he called it), and eighties hard-earned awareness. They're all over town, a-stirring.

This is house-to-house, block-by-block, pavement-pounding, church-meeting, all-kinds-of-discussion stuff that may, as we wake up some great gettin'-up morning, reveal a new kind of Chicago. Nick Von Hoffman, who for a time was Alinsky's right arm, said it: "You who thought of yourself, up to that moment, as simply being a number, suddenly spring to life. You have that intoxicating

feeling that you can make your own history, that you really count."

Call it a back-yard revolution if you want to. It will sure as hell confute the Johnny Da Pows of our day, the merchant princes and the Fast Eddies. And, incidentally, lay the ghost of Lord Acton: less powerlessness that corrupts and more power that may ennoble.

Perhaps mine eyes may yet see the glory.

‖‖‖ ‖‖‖ ‖‖‖

Glory, glory. I missed one such moment—
at least, the witnessing of such—in 1929.
Cubs Park. It wasn't so memorable for the
Hack, Rajah, Old Hoss, Jolly Cholly, Gabby,
and Kiki; but, oh, what a moment for an
overaged slow-baller, Howard Ehmke, who
hadn't started a game all year.

Jimmy O'Hair skipped Mr. Krout's Psych
I class at Crane Junior College, which was
terribly exciting, it being our first encounter
with *Gestalt* stuff and Sultan, the gorilla,
figuring how to connect the bananas above
with the stick below. Jimmy and I had
skipped class just the week before to see *All
Quiet on the Western Front* at the Chicago
Theatre.

So I said I can't when Jimmy said let's go
see the opening game of the World Series.
The Cubs were facing the A's of Connie
Mack. Grove, Earnshaw, Walberg, Simmons.
He was sure we'd make standing room and
we'd see the blazing fast stuff of Lefty Grove.
I didn't go; he did, and he saw Connie Mack
slip a fast one on Joe McCarthy's juggernaut
by putting in a slow one. Thirteen Cubs
whiffed, swinging crazily at a ball that was
only halfway home. And I missed seeing a
senior citizen, Mr. Howard Ehmke, touch
immortality. Damn.

Everybody who is anybody swears he saw Gabby Hartnett hit that home run in the dark and beat the Pirates out of the pennant. September 1938. An awful lot of Chicagoans must have had a dying grandma that day. Who minded the store?

The late Vincent De Paul Garrity, who was like no other, who was to the bone Chicago-bred—Cubs bat boy, Mayor Ed Kelly's office boy, Sanitary District trustee, who on radio could run off more precinct captains' names in fifteen minutes intermixed with about a dozen tributes to Chuckie English, Sam De Stefano, Murray The Camel, and Momo than the fastest tongue-twisting artist around—let me know in a casual aside that he was more than just there. "The crowd and the players got so excited, they picked him up at second base. I ran out and said, 'Put him down, he's gotta touch the bases.'"

Of course, everybody including all the no-bodies saw the Babe, in the '32 Series, point to right field before he laid into one of Charlie Root's pitches and put it exactly there. Wrigley Field in those days must have had a capacity of 250,000. At least. But not me. I heard it on the little radio perched on the transom of the lobby of the Wells-Grand Hotel. It just wasn't the same.

||||| ||||| |||||

Just as only my city could spring forth originals—Vincent De Paul Garrity, Mike Royko, Bill Veeck, and Maredaley—so it has given us as our own, my neighborhood bag lady.

The neighborhood where I live suits me fine. It has halfway houses, nursing homes, and all the United Nations' anonymous representatives, as well as Appalachians, Ozarkians, and Native Americans. And bag ladies, of course.

Unfortunately, poverty is its lot, though there is spirit enough for fifty neighborhoods. (I live on a have street in a society of have-nots. It is no more than a hundred yards away from the action, yet it is a planet distant.) At times, the dispiritedness of dreadful circumstance overwhelms, despite the efforts of ONE. It appears to crush. Yet there is a throb of life here, hardly found elsewhere. It's Uptown, of course.

A few months ago, I had trouble with the corner newspaper vending machine. I had dropped my quarter in for the morning *Trib*. It was the fourth quarter within a month I had lost to this mechanized predator. I kicked it. Hard. Again and again. I rammed my foot against it. I shook it as a maddened father shakes a recalcitrant child. I cursed it aloud. I was inventing a wholly new vocabulary of expletives. I was W. C. Fields in lethal com-

bat with the picket fence. I was losing the battle. I was about to surrender. Furious. Impotent. That's when she came along.

I had seen this bag lady several times before. She was hard to miss. Ageless, she tipped the scales at hardly more than one

hundred pounds. She usually bore two huge burlap bags that probably outweighed her, two to one. She wore two coats, whether it was 10 below or 90 above. She belonged.

As I gave the damnable monster one last whack, bruising my hand badly (I still bear a nasty scar), she joined me. She took over. She banged it with her elbow, with her shoulder, with her knee, with the exhilarating fury of her whole being. Once, twice, three times. It was three, the magic number. There was a rattling, as from a dying dragon. The quarters flew out, overflowing the slot. A Las Vegas jackpot. I plucked out four quarters. She scooped up the rest. She went her way. I went mine. Not a word was exchanged between us. Not even a glance. Yet we were kindred spirits. My kind of town, Uptown is.

|||||| |||||| ||||||

The one other time I remember such a moment of transcendence was my first visit to Orchestra Hall. I had more money in my pocket than any fifteen-year-old boy had a right to have. My father was as generous as my mother was tight-fisted. He wanted me to hear the kind of music he would never be able to hear again, his heart was that bad.

|||||| |||||| ||||||

Pa and his crystal set. Near his sickbed, a primitive contraption. We had no idea how it worked, he and I. Yet when we twisted that oh-so-thin wire, a silver thread, against that corrugated piece of crystal, a human voice came through or the tinkle of a piano or a scraped-violin sound. It wasn't the sort of music my father played on the old Victrola. There was no Caruso or Rubinstein or Kreisler here. Yet it held us fast.

Sen Kaney's voice was the first we had ever heard on the radio. He was the stentorian-voiced announcer on KYW, the most power-ful of Chicago stations. When he came

through that magic box, you sensed Authority; yet it was of the most congenial sort. If there was one attribute these voices had in common, it was Geniality. We had sudden, intimate friends visiting our bedroom. They could have sold us anything. And they did.

There was one voice, though, that most enchanted us. Wendell Hall, the Red-headed Music Maker. The smiling tall man and his ukelele. Not that he sounded like Segovia or even Eddie Peabody. It didn't matter. When he sang "It Ain't Gonna Rain No More," we knew that radio had arrived. He was no Bing, by a long shot, but oh, what that skinny little piece of wire could evoke. A wonder.

It ain't gonna rain no more, no more,
It ain't gonna rain no more.
How in the heck are you gonna wash your neck
When it ain't gonna rain no more?

And along came the *Tribune*'s station, WGN: acronym for World's Greatest Newspaper. My father and I were held transfixed, hour after hour, as Quinn Ryan was relaying a word-by-word, blow-by-blow account of the Scopes trial in Dayton, Tennessee. The Monkey Trial. My memory is playing tricks on me now: did we or did we not actually hear Darrow's voice and Bryan's? In any event, we were in on the matter of the mo-

ment. Did a small boy and his old man have the same experience in any other city?

When Vernon Dalhart sang of "The Death Of Floyd Collins," my father and I knew all about it. Quinn Ryan had been down there, near the Sandstone Cave in Kentucky, where the unlucky guide was trapped. It was the first time tragedy and commerce were fused on the airwaves. Ours was the dubious distinction of having been in on it from the very beginning.

Later, later, came the tubes, Atwater-Kent, Westinghouse, and all those super-heterodyne sets. And the Sunday Symphony. My father's last delights.

||||| ||||| |||||

It didn't seem too long a walk from Wells and Grand on that Saturday night. Way up in the gallery, I looked down at a tall, stork-like conductor. It was Eric DeLamarter, Dr. Stock's associate. Why do I remember him as bearing a resemblance to Eamon de Valera, the Irish president? He was conducting the symphony of a Czech who had visited America.

It was *The New World* in more ways than one. I was never to be the same boy.

In thinking of the Chicago Symphony Orchestra, the nonpareil, another jewel in our

city's crown, I feel, as Barry Byrne put it, a swelling of the chest. But it hardly matches the *bump*, *bump*, *bump* I experienced that Saturday pop night so long ago. From Frederick Stock's largely Teutonic repertoire to the more expansive worlds of Rodzinski, Reiner, and, now, Solti, there have been a lot of *bump-bump-bump*s, but nah, nah, nothing like my first discovering *The New World*.

Way down upon the Wabash
Such land was never known;
If Adam had crossed over it,
This soil he'd surely own;
He'd think it was the garden
He'd played in when a boy,
And straight pronounce it Eden
In the state of Elanoy.

||||| ||||| |||||

Stanley Cygan was seeking Eden, too, when he came to Chicago in 1909, after hard years of hard labor in the McKeesport steel mills. He had started at sixteen: "The boys coming from Poland, my age, they all worked hard. My mother said the Poles were downgraded in McKeesport. Go to Chicago, she told me."

Here, through all his tough work years at the rolling mills, he dreamed of books and school and finding something out. "I wanted

to be smart." He lost track of all the Hull-
House lectures he attended, forgetting his
aching muscles, listening hard.

"There was a professor lecturing on rela-
tivity." As he pronounces the word slowly,
enunciating every syllable, there is more than
awe; it is a wanting to possess the idea. "Ein-
stein." He caresses the name. "I'd spend an
hour and a half listening to the professor. But
the worst of it was I didn't understand half
the words he used. I never did understand
relativity. There's a lot of things I don't un-
derstand, that if I had more schooling I
would."

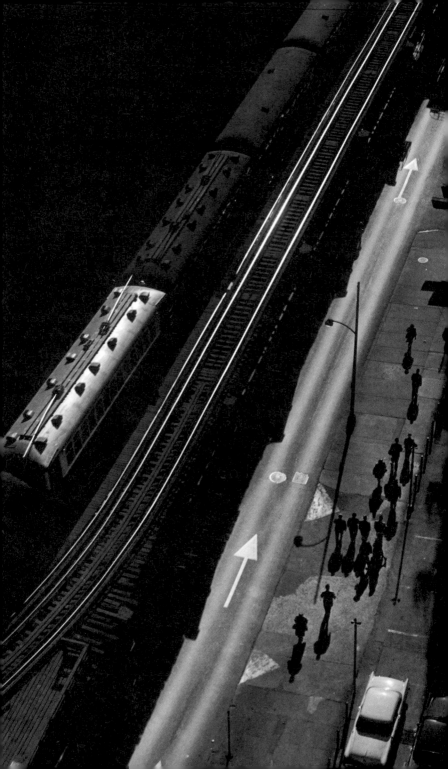

Eden had eluded Stanley Cygan. Chicago had to do till the real thing came along.

As for the boy who stepped off the day coach at the La Salle Street depot on that August day, 1920, he has come to know, ever so slightly, the nature of the Roman god who, fable tells us, guards the gates of heaven. He knows, too, that the spirit of this god hovers over Chicago. He further knows that Janus, two-headed, has, of course, two forked tongues. So the boy, in the ultimate, knows that, despite the song, he'll not find Eden here. Here, in Chicago, this cock-eyed wonder of a town, he is—and all of us are—twice blessed and twice deceived. And he'll settle for that.

||||| ||||| |||||

a f t e r w o r d

Consider what you've read a long epilogue to what is still the classic tribute to a city, Nelson Algren's Chicago: City on the Make. *The following is the foreword I wrote to its last edition.*

|||||| |||||| ||||||

"I love thee, infamous city!"

Baudelaire's perverse ode to Paris is reflected in Nelson Algren's bardic salute to Chicago. No matter how you read it, aloud or to yourself, it is indubitably a love song. It sings, Chicago style: a haunting, split-hearted ballad.

Perhaps Ross Macdonald said it best: "Algren's hell burns with a passion for heaven." In this slender classic, first published in 1951 and, ever since, bounced around like a ping-pong ball, Algren tells us all we need to know about passion, heaven, hell. And a city.

He recognized Chicago as Hustler Town from its first prairie morning as the city's

fathers hustled the Pottawattomies down to
their last moccasin. He recognized it, too, as
another place: North Star to Jane Addams as
to Al Capone, to John Peter Altgeld as to
Richard J. Daley, to Clarence Darrow as to
Julius Hoffman. He saw it not so much as
Janus-faced but as the carny freak show's
two-headed boy, one noggin Neanderthal, the
other noble-browed. You see, Nelson Algren
was a street-corner comic as well as a poet.

He may have been the funniest man around.
Which is another way of saying he may have
been the most serious. At a time when pimp-
ery, lickspittlery, and picking the poor man's
pocket have become the order of the day—
indeed, officially proclaimed as virtue—the
poet must play the madcap to keep his bal-
ance. And ours.

Unlike Father William, Algren did not
stand on his head. Nor did he balance an eel
on his nose. He just shuffled along, tap-
dancing now and then. His appearance was
that of a horse player who had just heard the
news: he had bet her across the board and
she'd come in a strong fourth. Yet, strangely,
his was not a mournful mien. He was forever
chuckling to himself and you wondered. You'd
think he was the blue-eyed winner rather than
the brown-eyed loser. That's what was so
funny about him. He did win.

A hunch: his writings may be read, aloud

and to yourself, long after acclaimed works of Academe's darlings, yellowed on coffee tables, have been replaced by acclaimed works of other Academe's darlings. To call on a Lillian Hellman phrase, he was not "a kid of the moment." For in the spirit of a Zola or a Villon, he has captured a piece of that life behind the billboards. Some comic, that man.

At a time when our values are unprecedentedly upside down—when Bob Hope, a humorless multimillionaire, is regarded as a funny man while a genuinely funny man, a tent-show Toby, is regarded as our president —Algren may be remembered as something of a Gavroche, the gamin who saw through it all, with an admixture of innocence and wisdom. And indignation.

"The hard necessity of bringing the judge on the bench down into the dock has been the peculiar responsibility of the writer in all ages of man." It was something Algren wrote in 1961, as an added preface to this book. It's a responsibility toward which he had been obstinately faithful. He was open-hearted to Molly-O and Steffi and Margo and Aunt Elly's "girl," who were forever up against it; who were forever in the pokey for turning a five-dollar trick with the wrong guy. (That fee is, of course, absurd today. You must remember his heroines subsisted long, long before inflation.) He's mail-fisted to their

judges, the Respectables, who turn a trick for no less than a hundred Gs. So, too, this piece of writing from the same essay:

"We have to keep Chicago strong and America mighty," I heard his Honor proclaim before sentencing the girl with a record for addiction. "A year and a day! Take her away!"

Blinking out of the window of an Ogden Avenue trolley at the sunlight she hadn't seen for almost a year, "I guess I was lucky I done that time," the girl philosophized. "Chicago still looks pretty strong and America looks mighty mighty."

Still nobody seems to be laughing.

What Algren observed twenty years ago applies today in trump. And in this prose poem put down some thirty-odd years ago— and what odd years they've been—the ring of a city's a awful truth is still heard. Only louder. As with all good poets, this man is a prophet.

It was no accident he wrote *The Man with the Golden Arm* so many centuries before posh suburban high schools fretted about junkies in their blue-eyed midst. The fate of Frankie Machine presaged adolescent hells to come.

In *Never Come Morning*, Algren gave us Bruno, the doomed young jackroller. How different is he, the desperate city ethnic, from the young black mugger? Law and Order is the cry today, as Algren so eloquently italicized the old poet's prophecy: "The slums will take their revenge." Call it ghetto, if you wish.

Yet I'm thinking of Algren, the funny man. The antic sense is there, of course, in Dove Linkhorn, the innocent hero of *A Walk on the Wild Side*. It is there in Frankie's colleague, Sparrow, the hapless shoplifter. It's there in Some Fellow Willie, who always looked suspicious because he always suspected himself of one thing or another. It's there in Lost Ball Stahouska of the Baldhead A.C.'s. He was something, that one. Remember when his conscience bothered him because he shoved an in-play baseball in his pocket, though he was unperturbed when cracking a safe with the help of three Chicago cops? As to the latter caper, Stahouska explained, "Oh, *everybody* does that."

Again, you have it. Turning a two-dollar trick is a sin and prickly to the conscience. Turning a hundred-thou trick, that's something else again. Lost Ball, were he around today, could well appreciate the workings of ITT, Lockheed, Penn Central, and the late Howard Hughes. Recurring in all of Algren's works—novel, short story, essay, poem—is

the theme of the rigged ball game. Offered in unique lyric style, they are memorable.

In his poetic evocation of the Black Sox scandal of 1919, he asks the ever-impertinent question: How is it that front-office men never conspire? How ever do senators get so close to God? Or winners never pitch in a bill toward the price of their victory?

Though today's literary mandarins have treated the man with benign neglect—he has in the past thirty years become something of a nonperson—he is highly regarded in unexpected quarters.

About eight years ago, in the streets of London, I ran into a voluble Welshman. On learning I was an American, let alone a Chicagoan, he bought me a whiskey. I had no idea Americans were so popular with the people from Rhondda Valley. It wasn't that at all. He could hardly wait to blurt out, "You're an American, you must know of Nelson Algren." He proceeded to rattle off, in mellifluous tongue, all the titles of Algren novels and short stories. On discovering that I actually knew the man, he bought me drink after drink after drink. And on a miner's pay, at that. How I got back to the hotel shall forever remain a mystery to me.

In New York, an old freight-elevator man, a small battered Irishman, whose one claim to fame was an encounter with Fiorello La-

Guardia, asked me between floors if I'd ever heard of a writer named Algren. He had read *The Neon Wilderness*. As far as I know, he owned no coffee table.

Recently, in a conversation with a woman on welfare, a Kentucky emigré, his name came up. It was she, not I, who introduced it. She had been reading one of his paperbacks and saw herself in it. She had also been having her troubles with the Welfare Department and neighborhood cops. As far as I know, she owned no coffee table.

Maybe Nelson Algren's horses always ran out of the money. Maybe his luck at the poker table was never that good. Maybe he was never endowed by a university. Still, he may have had good reason to shuffle along, a laughing winner. And maybe it is for this small work, as much as for his novels and short stories, he will be remembered.

It has been advertised that in his last years, Algren's feelings toward the city he so long celebrated had undergone a deep sea change: the ardent lover disregarded by a cold mistress had decided to end the affair himself, to kiss her off. He did indeed move away from Chicago, as far east as he could go. His bones do indeed moulder deep in Sag Harbor soil. Yet, this singular prose poem (or song) tells us something else: his heart lies buried, waywardly, somewhere in the vicinity of Damen

Avenue and Evergreen Street. His own lyrics
have lovingly betrayed him.

> *The Pottawattomies were much too square.*
> *They left nothing behind*
> *but their dirty river.*
> *While we shall leave, for remembrance,*
> *one rusty iron heart.*
> *The city's rusty heart, that holds*
> *both the hustler and the square.*
> *Takes them both and holds them there.*
> *For keeps and a single day.*

‖‖‖‖ ‖‖‖‖ ‖‖‖‖

t h e p h o t o g r a p h s

The Hungarian-born Stephen Deutch began his career as a sculptor and wood carver in Budapest and Paris. In the 1930s he moved to Chicago, where he opened a photographic studio and published photos in a variety of French and American publications, including *Coronet*, *Popular Photography*, *Fortune*, *Saturday Evening Post*, *Ebony*, and the *Chicago Sun-Times*.

Deutch's photo-exposé on the Mental Health Institute of Illinois was nominated for a Pulitzer Prize, his work has won scores of awards and honors, and several of his prints have been acquired by the Chicago Art Institute and the Chicago Historical Society. His career has also included numerous sculpture and photography shows, television documentaries, lectures, and demonstrations. In 1981 Deutch was the subject of a thirty-minute documentary filmed by Kathy Deutch Tatlock and screened in Boston, New York, and San Francisco.

||||| ||||| |||||

Chicago born and bred, Archie Lieberman was educated at the Institute of Design and has had his work exhibited in several Chicago galleries as well as other Midwestern institutions and New York's Metropolitan Museum of Art. Over the course of his career, Lieberman has shot photos for numerous national publica-

tions, including more than 120 stories for *Look* magazine. He is well known for several books produced in collaboration with writers as diverse as Ray Bradbury and Paul Tillich, as well as for the books *Farm Boy* and *The Israelis*, for which he was both author and photographer.

Lieberman's photographs are currently held by a broad range of museums and private collections, having garnered prizes and awards from the Chicago Art Directors, the Society of Typographical Arts, the Chicago Book Clinic, and the University of Missouri School of Journalism, among others.

‖‖‖ ‖‖‖ ‖‖‖

Marc PoKempner's interest in photojournalism emerged during his student years at the University of Chicago, where he was photo editor of the *Maroon*, documenting musical events and political demonstrations of the 1960s. He then studied with Minor White at MIT, where he was also employed as MIT's official news photographer. Returning to Chicago to document the Chicago blues-club scene, PoKempner began work for the *Chicago Reader*, an alternative weekly.

PoKempner's photographs have appeared in *People* magazine, *Time*, *Newsweek*, the *New York Times Magazine*, *Business Week*, *Fortune*, *Forbes*, *Parade*, *Sports Illustrated*, *Stern*, and many other publications. He is currently at work on several projects: assembling the documentary blues photos into a book, documenting everyday life in Cuba in the 1980s, and photographing the works of the Chicago Housing Authority and the Cook County Hospital.

Arthur Shay, a former *Life* magazine reporter and bureau chief, became a free-lance photojournalist in the early fifties. More than 25,000 of his pictures have appeared since then in *Time*, *Life*, *Fortune*, *Sports Illustrated*, *Forbes*, *Business Week*, *Parade*, and other publications. During the sixties and seventies he covered the human rights movement for *Time* and *Life* and also did the photography for some fifty of *Life*'s mafia crime stories, often with hidden cameras. He has also illustrated eight health-care books for the Blue Cross.

An award-winning racquetball player, Shay counts nine books on the sport among some seventy he has done for Contemporary Books in Chicago. He is also active as a playwright and a literary critic, and occasionally as a journalist.

Richard Younker was born in Chicago and received his B.A. from the University of Chicago in 1963. For the next ten years he worked as a mailman, sixth-grade teacher, encyclopedia salesman, public aid caseworker, actor, and singer. For the past twelve years he has been a photojournalist. He has done assignments for various national publications, corporations, hospitals, and universities. Twenty-five of his photo-essays, ranging in subject from commercial fishermen and a farm veterinarian to racetrack characters and street gangs, have appeared in the Sunday magazines of the *Chicago Tribune* and the *Chicago Sun-Times*, and reflect his

interest in mostly blue-collar workers (both rural and urban) and street life. His first book collaboration, *On Site*, documented the world of tradesmen on a construction site. Younker also provided the photography for *Street Signs Chicago*, a book about Chicago neighborhoods.

Born in 1912, Studs Terkel grew up in Chicago. He graduated from the University of Chicago in 1932 and from the Chicago Law School in 1934. He has acted in radio soap operas, has been a disk jockey, a sports commentator, a TV m.c., and has traveled all over the world doing on-the-spot interviews. Currently, he has a daily radio program on WFMT, Chicago, which is carried on other stations throughout the country.

His previous books, Division Street: America, Hard Times, Working, Talking to Myself, American Dreams: Lost and Found, *and* "The Good War," *have received international acclaim and were all best-sellers in the United States. His books have been translated into every major Western language as well as Hungarian and Japanese.*

Studs Terkel lives in Chicago with his wife, Ida; they have one son, Paul.

The text for this book was set on the Linotype in Monticello, a revival of the original Roman No. 1 cut by Archibald Binny and cast in 1796 by the Philadelphia type foundry Binny & Ronaldson. The face was named Monticello in honor of its use in the monumental fifty-volume Papers of Thomas Jefferson, *published by Princeton University Press.*

Production and manufacture of this book directed by Kathy Grasso.
Book design by Susan Mitchell.
Composition by Maryland Linotype Composition Company, Baltimore, Maryland.
Printing and binding by Arcata Graphics/Halliday Lithographers, West Hanover, Massachusetts.